30-Minute Watercolor Painting for Beginners

30-MINUTE
Watercolor Painting
for Benginners

Easy Step-by-Step Lessons and Techniques

ROCKRIDGE
PRESS

Every artist was first an amateur.

RALPH WALDO EMERSON

Contents

Watercolor Painting 101

Humans have used paint to leave our mark on the world since the early days of civilization. From prehistoric cave paintings to the fresco ceiling of the Sistine Chapel, across ancient scrolls and fine silk garments, water-based **pigments** have always been present in art and design. Watercolor is, to this day, one of the most popular painting mediums, owing to its **expressionist**, fluid quality and versatility. Fortunately, the natural interplay of water and pigments can create lovely imagery even for novice painters. With the techniques outlined in this book you will learn to produce your own beautiful watercolor works.

In the pages to follow, this book will guide you upon the well-traveled journey of painting with watercolors. Part I includes all the information you'll need on the materials and tools, followed by five key lessons in basic techniques. You'll then be ready to progress to part II, which contains fifteen beautiful painting projects with clear step-by-step instructions to help you expand your abilities in stages. With every lesson and project planned to take thirty minutes at most to complete, you'll be able to master the basics of watercolor in enjoyable, bite-size sessions that can fit into even the busiest of lifestyles.

Materials and Equipment

As with any creative process, tools and materials help shape the outcome of your work. This section will cover the range of equipment and materials recommended for a beginner working their way through the lessons and projects contained in the following pages.

Watercolor Paints

Before you put brush to paper, it's important to understand your paints and how they will react. Watercolor paints are produced by blending a pigment with a suspension material, such as synthetic glycol or gum arabic, to form a lustrous, flexible substance that can cling to a canvas. In contrast to acrylic or oil paints, watercolors are almost always combined with water before being applied in thin layers.

Watercolor paints are primarily sold as either liquid in tubes or as dry solid paint blocks, called cuvettes, in metal tins. These tins are portable, storable, and convenient for **plein air** (outdoor, on location) painting, making them a great option for beginners who may not have a dedicated painting space. Liquid watercolors are advantageous for when you need to cover a large area with a particular **shade** or want to work with a strong, opaque color, as they are easier to mix on a palette without adding as much water. Keep in mind that even in a tube, the paint can dry if the cap is left off, so always make sure you wipe the end of the tube clean to ensure the cap fits snugly.

When it comes to quality, student-grade paints are cheaper and ideal for when you are still coming to grips with the basics. Once you begin to feel more confident, it may be worth investing in some professional-grade paints, which will yield richer colors. Adapting to the differences in the way paints behave can take time, so try taking notes of your progress, referring to projects you've already completed, and reading a project's suggested tips.

For the projects in this book, a basic set of 8ml to 10ml tubes of paints or a tin of cuvettes will serve you well. Each painting will use **hues** from the following list, which are included in many starter sets.

- Ivory Black or Lamp Black
- Cerulean Blue
- Crimson Red
- Viridian Green

- Yellow Ochre
- Cadmium Red* or Vermilion
- Burnt Sienna
- Ultramarine Blue

- Burnt Umber
- Chinese White or Titanium White
- Cadmium Yellow*
- Lemon Yellow

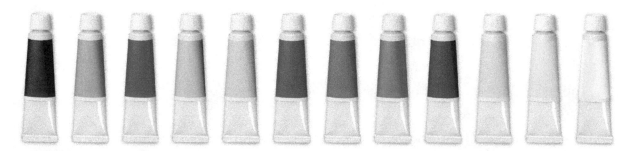

*Be particularly careful when using cadmium paints, as accidentally ingesting them (or overexposure over a long period of time) can cause adverse health effects.

Paper and Canvases

The paper you use will impact how your paints spread across the page. Thin sketchbook paper is unsuitable for watercolor, as it will sag and tear when damp, and **gesso**-primed acrylic or oil canvases may repel the water-based paint. Instead, look for specific watercolor paper at your local craft store, and opt for a heavier, thicker paper when possible. Absorbent paper typically contains cotton, which allows the watery paint to saturate the surface, making it easier to control and quicker to dry. It also tends to last longer than cheaper papers, which will yellow over time. However, thicker paper can be more expensive, so it is completely okay to start with more budget-friendly options. Refer to the list of paper, blocks, and canvases below to guide your purchases based on your desired effects.

Rough paper is useful for adding **texture** to your paintings, as well as darker **tones**, as the texture captures more light. It absorbs water quickly, which can prevent pooling but also allows less time for mixing on the paper itself. A rougher surface texture lets you paint loosely and expressively but makes fine brush strokes less accurate.

Smooth paper is useful for adding in details, as it absorbs water more slowly. It allows for better on-paper mixing but requires an even hand to control the water. While excellent for thin brushes and pencil sketching, it is less advisable for wet **washes**, which will warp the paper.

Watercolor blocks suspend the paper and stretch it out, allowing the work to dry more quickly and preventing the paper from warping. However, this also means you have less time to work with the paint before it dries.

Watercolor sketchbooks tend to be smaller and contain slightly thinner paper, but they are cheap and portable. They are suitable for small, quick paintings and practice, but won't hold a wet wash very well.

Watercolor pads are thick boards that can be transported easily. The texture is usually rougher than a sketchbook, and the pages can be torn out for individual paintings secured with masking tape.

Watercolor canvases allow for richer textures and won't bend and sag when damp. They are more expensive but wonderfully stage particularly precious works.

Drawing Pencil

Watercolor can be an expressive art form, but when starting out, it can be beneficial to use pencil sketches to guide your painting. A drawing pencil will be used to sketch out the basic lines and shapes of your painting. When selecting a pencil, you'll want to avoid anything too soft, and avoid charcoal pencils, as they can smudge easily when watercolor is applied. Instead, select a graphite pencil with medium lead and a sharp tip. An excellent pencil to try is a number 4 pencil (a 2H on the graphite scale).

FIVE TIPS FOR PENCIL SKETCHING

Sketching with pencil first is an easy way to give yourself a clear blueprint for your painting. The pencil lines can serve as a guide for the big picture lines and shapes, but also for the details. Follow these tips to get the most out of your sketches.

1. Select your paper type: For a looser sketching style, opt for the rougher cold press paper; however, for a tighter, more controlled style, the smoother surface of hot press paper is best.

2. Sketch gently: Apply as little pressure as possible, leaving only a faint mark to give you an indication of your image's composition. This will allow you to erase it later if you wish.

3. Don't overwork your paper: Try practicing your drawing on plain paper before moving on to watercolor paper to prevent overworking it, which will make it harder for your paint to stick.

4. Use a special eraser: There are different kinds of erasers. When painting, always use a kneaded eraser, which is soft and malleable and less likely to rip your delicate watercolor paper.

5. Keep your paper clean: If you do use an eraser, make sure to blow away any little specks of rubber. If they become mixed in with your watercolor wash, the painting will end up with lots of small, dark spots where the debris has soaked up paint.

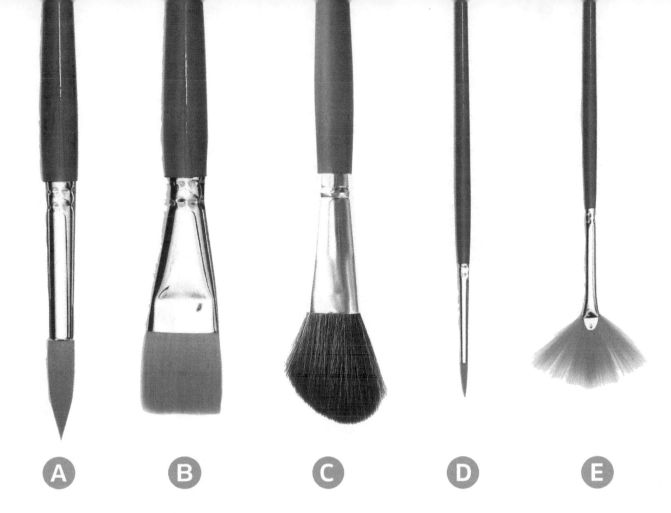

Paintbrushes

When starting out with watercolors, a small selection of brushes is sufficient to learn the basics and develop your technique. Most projects in this book will make use of a small round brush and a larger flat brush, but to complete all projects we advise purchasing the following:

A. **Number 4 and number 8 round brushes.** Round brushes can perform a variety of functions depending on their size—smaller ones can be used for details and larger ones are great for washes. When selecting a round brush, look for those that can form a fine tip at the end when wet.

B. **¹/₂-inch and 1-inch flat brushes.** Flat brushes are efficient at creating straight-lined strokes or filling in larger empty spaces quickly.

C. **Approximately ³/₈-inch mop brush.** Mop brushes, or wash brushes, are designed to create curvy, smooth, expressive effects in broader strokes. Their tips can be tightened for very thin linework as well.

D. **Number 1 rigger brush.** Rigger brushes are small, thin brushes with long bristles. They are best for long wispy lines but can also be used to apply texture to a piece.

E. **Fan brush.** Fan brushes are shaped like their name suggests. They are great for creating texture effects.

Additionally, when purchasing brushes, keep in mind the differences between synthetic and natural hair. Synthetic brushes tend to be cheaper, can hold their shape more easily, and can form

points better. However, they are worse at holding on to larger amounts of paint, which can create an uneven spread. Natural-hair brushes tend to be more expensive but, if taken care of properly, can last much longer. They can retain paint better and distribute it more consistently. Different types of hair can produce different results, so it could take some experimentation to find the type of natural brush that feels right for you.

When it comes to maintaining the health of your paintbrushes, ensure you are using a brush only for its intended use. Be careful not to "scrub" cuvette paint with your bristles when collecting pigment. Using liquid paints can help prolong the life of a brush. Try to avoid splaying the bristles when painting. Clean out your brushes properly after use, especially if you're using tap water when you paint.

Natural-hair brushes should be treated with even greater care than synthetics. Going overboard with soap or other cleaners can damage them. A gentle rinse and **dab** will suffice.

Also take care of the **ferrule**, the metal piece that holds the base of the bristles together. If this piece gets damaged or paint-logged, it can greatly deteriorate the quality of the brush. Don't soak your brushes in water, as this will warp the bristles and, over a prolonged period, could cause them to fall out or cause the ferrule to detach.

Finally, after washing and drying your brushes, shape the tip into a fine point and store your brushes laid down flat. Never store brushes with the tip facing down, as it will warp the bristles.

MIXING PAINTS IN FIVE STEPS

Follow these steps to properly mix your watercolor paints every time.

1. **Decide on the color you want and determine what colors it is made up of.**

2. **If you're using liquid paint, press a tiny amount of your colors onto the palette, close to each other but not touching. For dry paint, wet your brush, then take some of your first color and apply it to your mixing palette. Clean your brush in water, then collect some of your second color, placing it near the first.**

3. **Use a very wet brush to wet the space between the colors, drawing some of each into the mixing area.**

4. **Add more water or draw more paint into the mixture until you are satisfied with the color and intensity.**

5. **Make sure that your brush is saturated in mixed paint. If your brush has any leftover bits of either individual paint color, rinse it before loading it with your paint mix. Begin painting with the new color you've created.**

Mixing Palette

A mixing palette lets you pre-mix different shades of paint before applying them to your canvas. This is especially important in watercolor painting as you will generally want to pre-mix paint with water even if you are not combining different colors. Many modern mixing palettes sold in art stores will include multiple wells for storing different colored paints and a separate space for mixing. These are useful to have when using multiple colors, to avoid inadvertent contact between them. You can use a plate or lid as a makeshift palette, but try to select something that matches the color of your paper. The color surrounding a paint can affect how the paint appears to your eye. Plastic party plates can be a good, cheap choice to mix watercolor paints as a beginner.

Additional Supplies

There are various other supplies, mostly household items, that will be needed or helpful when completing the projects in this book. They include:

Masking fluid: A liquid that can be applied to small areas on your canvas and painted over when dry. After the paint has dried, the masking fluid can be removed, leaving behind a clean white canvas.

Water glasses or jars: Keep two glasses of water handy—one for rinsing paint off a brush and the other for wetting it with clean water.

Masking tape: A tape used to secure a sheet of paper or canvas pad onto your work surface, to leave a clean white border when removed.

Paper towels: Useful for soaking up any excess water or spills, and for drying brushes.

Sponges: Used to dab at the canvas and soak up excess watery paint, leaving a textured pattern on the paper.

Kitchen salt: A small amount can be scattered onto a wet wash to create a starry effect.

Wax crayon (white): Wax is water-repellent, so a wax crayon can be used to define areas where you do not want any color to settle, even when applying a color wash over the top.

Watercolor Foundations for Beginners

This section will explore some of the core principles of watercolor painting. An understanding of the fundamentals is essential for building your skills throughout the rest of the book.

Color Theory

Color theory explains how different shades of color interact based on how they are combined. The **color wheel** is a visual tool designed to show the interaction between primary, secondary, and tertiary colors. It clearly illustrates the ways that the different colors interact and can be a helpful guide when mixing the precise shades required for a painting.

PRIMARY COLORS

The primary colors are red, blue, and yellow. They are important because they cannot be created by mixing other colors, but a combination of two or more primary colors can create any other color on the color wheel. To achieve a lighter shade, you can mix each primary color with water. The higher the ratio of water to paint, the more translucent the pigment will be. You could instead combine with white paint for a more opaque but lighter, less saturated color.

SECONDARY COLORS

The secondary colors are created by mixing two primary colors and are shown at the central point between the primary colors on a basic color wheel diagram. Yellow and blue create green, blue and red create violet, and red and yellow create orange. You can create a variegated wash with a secondary color and one of its two primary colors to produce a pleasing **gradient**.

TERTIARY COLORS

The tertiary colors are created by mixing primary and secondary colors together. For example, yellow and orange will create an amber shade, red and purple combine to form magenta, and blue and green mix to make teal. Basic watercolor sets often contain secondary and even some tertiary colors pre-mixed, so it can be helpful to experiment and make your own color mixing chart with the paints you have on hand.

COMPLEMENTARY COLORS

Complementary colors exist on opposing ends of the color wheel. The way they contrast boldly against each other draws the eye to the area and accentuates the intensity of both colors. Blue and orange, red and green, and yellow and purple are all complementary color pairs. With watercolors, be careful not to let complementary colors **bleed** into each other when wet, as they will mix and form a murky brown.

COLOR PALETTES

A color palette is a selection of colors that is used to create a painting. You can select a color palette that contains paint of similar hue or tone, or one that features contrasting colors. In this book, we will highlight two prominent color palettes in watercolor painting: warm and **cool palettes**. Warm colors lean more toward reds and yellows, while cool colors skew toward the blue side of the color wheel. By using only colors from the same part of the color wheel, you can give an entire image a strong tone and affect the overall mood of the piece. For example, **warm palettes** can give

A COLOR WHEEL

a cozy or nostalgic feeling, while cool palettes might feel mysterious or melancholic. Additionally, warm colors can help an image feel like it is closer and more intimate, while cool colors can help enhance a sense of scale and distance.

VALUE SCALE

The **value** scale refers to how light or dark a color is. Using different values in a piece creates layers of **depth** and can be used to imply lighting and shadows. For example, an orange painted under strong spot lighting will be a lighter shade on one side, transitioning across its value scale to a darker shade on the opposite side, creating the illusion of a light source beaming upon it.

Composition

The **composition** of a painting refers to the way its elements are laid out within the space, and how the placement of different aspects synergizes to draw the viewer in to the image. In watercolor painting, it is important to consider composition from the outset, as it is much more challenging to rearrange elements or correct errors once you have begun to paint the image, due to the way water-based paint layers. It is usually best to finalize your composition at the pencil-sketch stage.

RULE OF THIRDS

The **rule of thirds** is a theory of visual design where, if you split an image into three segments horizontally and three segments vertically (nine equal-size segments in total), the edges of the key elements within the composition will be aligned with the dividing lines. Following this principle makes for imagery that is more dynamic in its layout, which is more appealing to the human eye. By structuring your paintings in a way that divides key imagery in this fashion, it can help increase visual interest and guide the viewer's gaze.

THE PAINTING'S ELEMENTS

When composing your painting, consider a range of elements such as color, value, line, and shape. Space is also important to consider. The way you fill the canvas—how busy or empty each area of your painting will be—will affect the sense of movement and direction in your composition. Another important element is depth, which can be achieved by creating a sense of **foreground** and **background**, using darker and more saturated values in the foreground (generally toward the bottom of the canvas) and lighter, less saturated values in the background.

WARM VERSUS COOL DOMINANCE

When deciding on what kind of tone you want your painting to have, carefully consider your color palette. Choosing a warm or cool palette can give your painting extra emphasis on the atmosphere you want it to convey. When using a color palette in this way, try to make sure that palette is used consistently and clearly dominates over other possible palettes. For example, a painting with a warm palette would strongly feature reds, oranges, and yellows, while areas of cool color would be reserved for small details or areas of contrast.

Light Source

Lighting is a pivotal aspect of almost any visual design that depicts scenes, characters, or realistic objects. Simply moving a light source or changing its intensity and color can dramatically affect the way a scene feels. The presence or absence of shadows plays into this. When setting up a painting, even if it's a simple object, deciding on a light source that will help give your painting

the tone you desire can make a big difference. When starting out, painting a still life of even a simple physical object, such as a piece of fruit, set up with a strong light source, such as a desk lamp, can help you learn how different shapes and textures react to light and how shadows form. For subjects you can't study from life, you could study photography or observe an object with similar form and texture, or a scene under similar lighting. Figuring out gradients to work with for your chosen color palette can also help you achieve the appearance of a light source.

Before You Start

Set up your workspace and secure your paper or canvas with masking tape. Read through the lesson and prepare the tools you will need for later steps.

When preparing any wash, note that it is necessary to produce enough paint for the area you plan to use it for. It's always better to have too much of a shade of paint than not enough, especially since watercolor shades can be difficult to replicate exactly. Additionally, for large swatches of color, you'll want the paint to be a darker or a more vibrant shade than your desired result, as the color will lighten during the drying process.

If possible, having your paper taut at the edges (using masking tape to secure it) as well as aligned at a slight tilt downward can help your watercolors run together as you paint from top to bottom, enabling you to brush over the remnants of one stroke with the next.

Watercolor Washes

A watercolor wash is a technique used to set up backgrounds or layer colors. It features big swathes of watery paint that cover a large area. There are different techniques that give different wash effects, and this section will cover the five used in this book.

WET FLAT WASH

Goal: Cover your paper with an even coating of a single color

Brushstroke: Broad, even strokes with a flat or mop brush

How To:

1. Wet your brush with clean water and apply it across your paper so you have a thin coat of liquid, beginning at the top and working your way to the bottom.

2. Select a color of paint. Fully and evenly load your brush.

3. Start at one of the top corners of your paper, laying your brush squarely against it with the bristles touching the corner. Slowly move the brush toward the opposite corner in one smooth, horizontal stroke.

4. Before the paint dries, reload your brush and repeat this process, overlapping slightly with your previous stroke so you can sweep up the band of paint left over from the last stroke and smooth it over.

5. Repeat this process until you have filled your space. Avoid repainting areas too much to maintain a steady shade.

WET-ON-DRY FLAT WASH

Goal: Cover your paper with an even coating of a single color

Brushstroke: Broad, even strokes with a flat or mop brush

How To:

1. Select a color of paint. Fully and evenly load your brush.

2. On dry paper, pick one of the top corners, laying your brush squarely against it with the bristles touching the corner. Slowly move the brush toward the opposite top corner in one smooth, horizontal stroke.

3. Before the paint dries, reload your brush and repeat this process, overlapping slightly with your previous stroke so you can sweep up the band of paint left over from the last stroke and smooth it over.

4. Repeat this process until you have filled your space. Avoid repainting areas too much to maintain a steady shade.

WET-ON-WET WASH

Goal: Cover your paper with different colors, letting the paint spread naturally on the wet surface

Brushstroke: Splotches of paint dabbed with a medium round brush

How To:

1. Choose two or three colors that complement your subject. For example, for the surface of a lake, you might select Ultramarine Blue, Cerulean Blue, and Viridian Green.

2. Wet your brush with clean water and apply it across your paper so you have a thin coat of liquid, beginning at the top and working your way to the bottom.

3. Load your brush with one of the colors and dab it somewhere on the page, letting the paint spread out.

4. Add splotches, lines, strokes, etc. of the other colors you've chosen, allowing them to bleed together. Try to maintain some distance between the marks to prevent your colors from washing into a brown shade.

5. Add a bit more water as needed, but take care to regularly rinse your brush.

GRADIENT WASH

Goal: Create a single-color gradient that gradually dissolves to white

Brushstroke: Broad strokes with a flat or mop brush

How To:

1. Choose any color to create a gradient with. Start with a tiny amount on your palette and add enough water so that the color is smooth but still vibrant. Load your brush with this color.

2. Begin at one of the top corners of your paper and paint a clean horizontal stroke to the opposite top corner.

3. Before the paint dries, reload your brush and repeat this process two or three times, overlapping slightly with your previous stroke so you can sweep up the band of paint left over from the last stroke and smooth it over.

4. Rinse your brush and load it with water. Mix the water into the paint on your palette to make it more translucent.

5. Make two or three more horizontal strokes, slightly overlapping your previous stroke as you work your way down, until you have used up the paint on your brush.

6. Repeat steps 4 and 5, increasingly watering down the paint on your brush and making strokes until you have a complete gradient that starts out vibrant at the top and grows faint at the bottom.

VARIEGATED WASH

Goal: Create a gradient of two colors on opposite edges of the canvas or area, which blend toward the center

Brushstroke: Broad, even strokes with a flat or mop brush

How To:

1. Choose two colors that are next to each other on the color wheel, such as red and orange for a sunset, yellow and green for a leaf, or blue and purple for a night sky.

2. Lay your paper down flat and load your brush up with the first color.

3. Beginning at one of the top corners of your paper, paint a clean horizontal stroke to the opposite top corner.

4. Continue making horizontal strokes, overlapping them slightly to collect the excess paint of your previous stroke and prevent banding, until you have filled in about one third of the page. Reload your brush and repeat as needed.

5. In your palette, start to mix the tiniest amount of your second color into your first. Apply it to the canvas in another horizontal stroke, overlapping with the last stroke of the first color. With each following stroke, mix in a tiny bit more of your second color of paint.

6. Continue making horizontal strokes, adding a little more of the second color to your mix, and less and less of the first, making sure to keep the overall **saturation** consistent with the ratio of water to paint. By the last few strokes (about the lower third of the page), you should be working with the second color only.

A Note About Drying

As a beginner watercolor artist, you might ask the question "To dry or not to dry?" When you're working with your watercolors, the emphasis should be on not overloading or flooding the paper with water. The drying time should be short in almost all of the painting steps (as the goal is to finish within thirty minutes!), so it's important to use as little water as necessary. You'll eventually get a feel for when you want to keep painting as to let the colors bleed into each other, or when to stop and let the paint dry before moving on. It's helpful to also keep a scrap piece of watercolor paper on hand to test consistency and remove excess paint during detailed work.

Introduction to Color: Simple Sunset

Our first lesson will cover the basics of mixing colors, producing a wet-on-wet variegated wash, and layering paints wet-on-dry. Learning to combine colors and manipulate them on your canvas is necessary for all paintings, and creating a variegated wash is helpful for producing backgrounds in landscapes.

MATERIALS: Watercolor pad or canvas, masking tape, palette, 2 jars of water, 1-inch flat brush, number 8 round brush, pencil, number 4 round brush

COLOR PALETTE: Ultramarine Blue, Crimson Red, Cadmium Yellow, Ivory Black

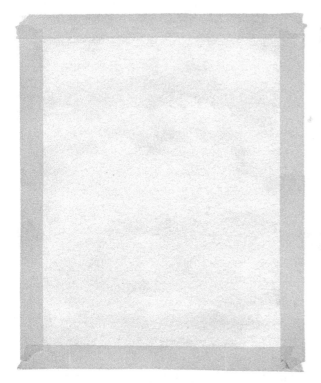

STEP 1: Load up your 1-inch flat brush with clean water and apply it to the page in even strokes, starting at the top, until the whole page is slightly damp.

STEP 2: Add a tiny amount of Ultramarine Blue and Crimson Red paint to your palette. Use your number 8 round brush to combine the paint with water until you create an even shade of purple. Apply this color to the top fifth of your wet paper using smooth horizontal strokes. Wash your brush.

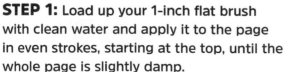

STEP 3: Mix some Crimson Red with water. Apply it to the canvas in horizontal strokes, starting in the middle of the purple section. Continue down the paper in horizontal strokes. As your brush runs out of color, wash it and reload with the Crimson Red mix to create a gradual color shift. When you are another fifth of the way down the page, wash your brush.

STEP 4: Mix Crimson Red and Cadmium Yellow to create about a tablespoon of orange paint. Continue your wash, overlapping with the red, down another fifth of the page. Wash your brush.

STEP 5: Mix a little Cadmium Yellow into the leftover orange paint and continue the wash with this shade until there is only one fifth of the page left unpainted. Wash your brush.

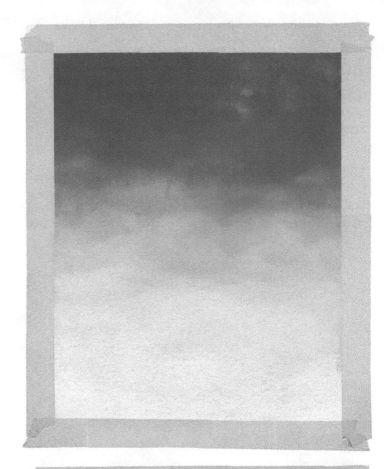

STEP 6: Mix some Cadmium Yellow with water, and then use horizontal strokes to cover the remaining section of canvas with this wash. Clean your brush and allow the paper to dry undisturbed.

STEP 7: When your paper is fully dry, use your pencil to sketch a row of pine trees with full, bushy branches. Vary the sizes and heights to give the illusion of depth.

STEP 8: Mix some Ivory Black paint with just enough water to allow it to flow easily. Using a number 4 round brush, pick a narrow, tight part of the sketch (like the top of a tree or a branch end). Paint the trees by positioning your brush tip in the narrowest part of the image, then sweeping it outward to fill in larger areas. Load your brush with more paint frequently, and continue painting until all the trees are filled in. Let dry, then remove your masking tape borders.

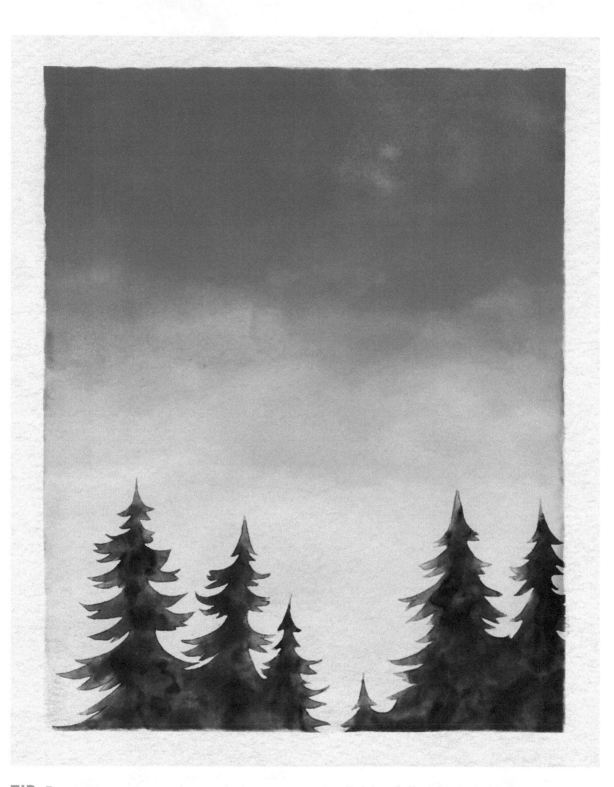

TIP: For even coverage when painting wet-on-dry, finish a full section before moving on so that you are working in the same area while the paint is still wet. Otherwise you'll end up with patchy coverage where wet paint has layered on dry.

Introduction to Shapes: Bright Balloons

Being able to turn a basic shape into an object with depth is a core skill of painting. This second lesson will cover how to paint dimensional shapes using **graduated opacity**. A bright bunch of balloons is a simple, cheerful subject, but the same technique is useful in any still life painting.

MATERIALS: Watercolor pad or canvas, masking tape, pencil, mixing palette, 2 jars of water, number 8 round brush, number 4 round brush

COLOR PALETTE: Cerulean Blue, Crimson Red, Cadmium Yellow, Viridian Green

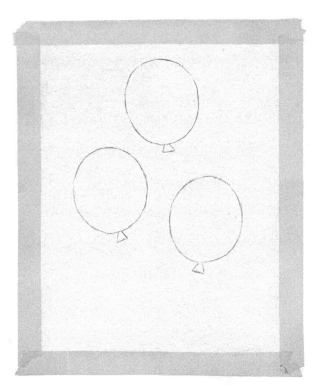

STEP 1: Make a light pencil sketch of the three balloon shapes. They should be roughly evenly spaced, with room at the bottom of the page for the strings.

STEP 2: Next, use the number 8 round brush to wet the paper around the balloons, bringing the water up to the edge of the pencil lines but not over them.

STEP 3: Mix a watery Cerulean Blue. While the paper is wet, work the blue paint over the background area, around the balloon shapes. Work down the page and use horizontal strokes wherever possible. The paint will spread out naturally toward the edge of your sketch. Wash your brush and let the paper dry.

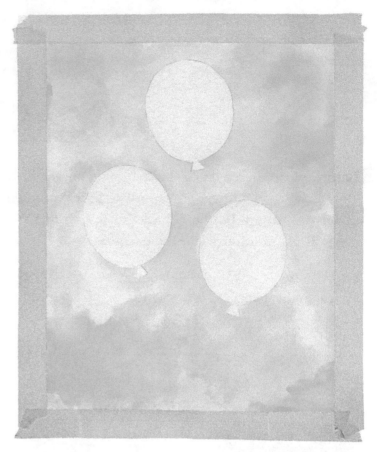

STEP 4: Using a number 4 round brush, mix a strong Crimson Red and apply it to the lower left edge of one balloon.

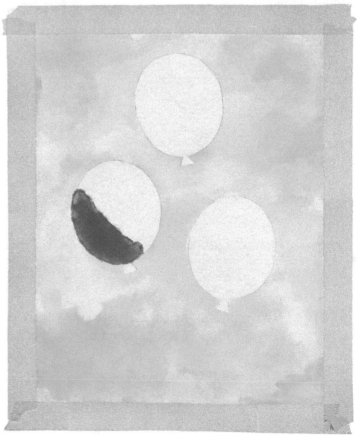

STEP 5: As quickly as you can, clean your brush and then dip it in clean water. Start in the center of the balloon, then bring your brush to the edge of the wet red paint, drawing the paint to mix into the water. Repeat this method, drawing the red paint around the edge of the balloon in a crescent shape.

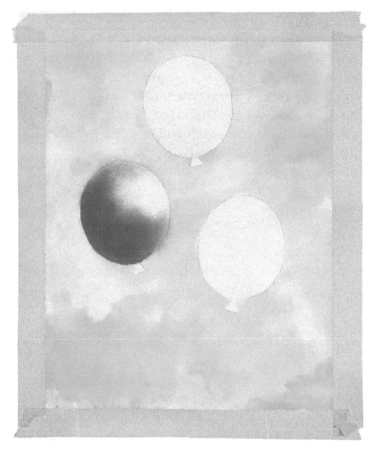

STEP 6: To finish this balloon, pick up a little bit more watery Crimson Red and use it to close up the gap on the top right part of the shape, leaving a small section of canvas showing through in the upper center to create a highlight effect. Fill in the balloon's knot.

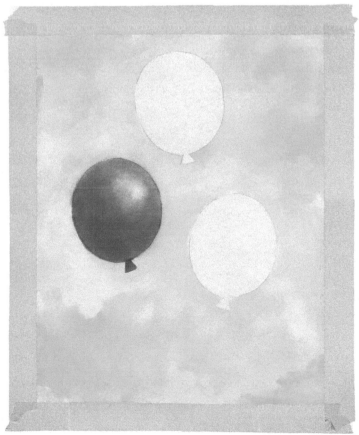

STEP 7: Repeat steps 4 through 6 to paint the other balloons. For the yellow balloon, start with an orange mix of Cadmium Red and Cadmium Yellow, then draw it out with a watery yellow instead of clean water. For the green balloon, use a mix of Ultramarine Blue and Viridian Green for the shadow side, drawn out with a watery Viridian Green.

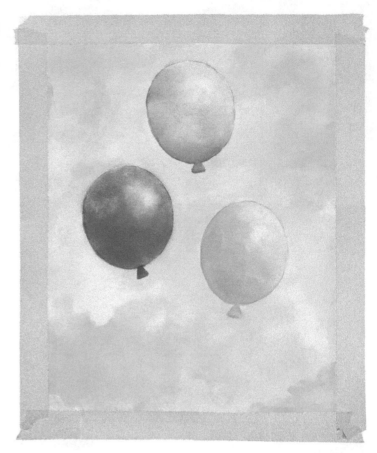

STEP 8: Use a pencil to draw thin threads dangling from each balloon. When the painting is fully dry, carefully remove the masking tape around the border to finish.

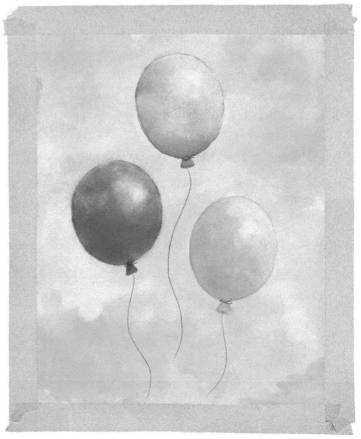

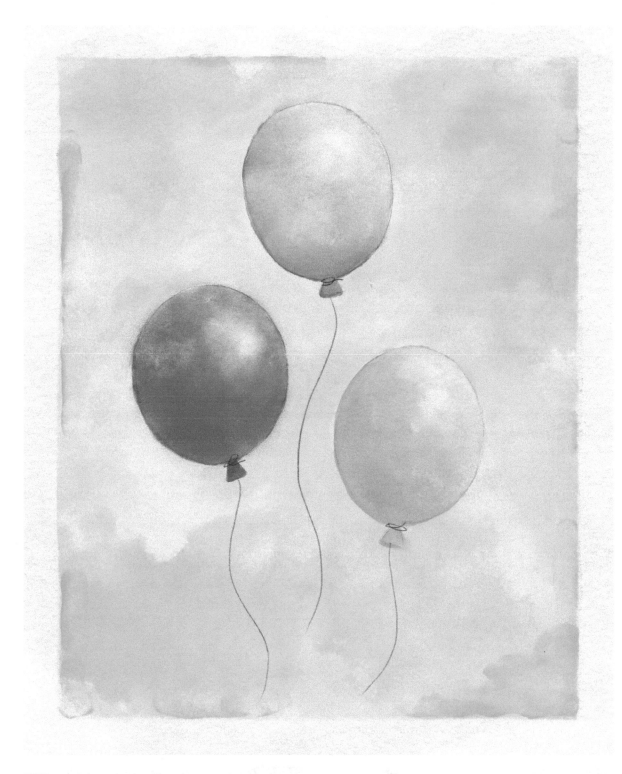

TIP: While a watercolor wash can be laid across a full page if you're working with darker values on top, as in Lesson 1 (Color, page 14), it will affect the color and vibrancy of lighter paint, such as our balloons. To create **negative space** on a canvas, you can also use masking fluid or masking tape.

Basic Brush Exercises: Lines and Dots

Painting doesn't always have to be **representational**; **abstract** patterns are both fun and help you learn some basic techniques. This lesson explores some basic lines you can make with your brush and builds confidence with shapes of different sizes.

MATERIALS: Watercolor pad or canvas (rough cold press), masking tape, mixing palette, 2 jars of water, 1-inch flat brush, number 8 round brush, number 4 round brush, pencil, number 1 rigger brush

COLOR PALETTE: Cerulean Blue, Cadmium Yellow, Crimson Red, Ivory Black

STEP 1: Prepare a thin wash using a tiny amount of Cerulean Blue. Using your 1-inch flat brush, cover your canvas with the wash, starting at the top in horizontal strokes and moving down. Let dry.

STEP 2: Use a more saturated load of Cerulean Blue to form two circles on your paper. Try using a number 8 round brush for one and a number 4 round brush for the second. Wash your brushes when done.

STEP 3: With a clean 1-inch flat brush, mix Cadmium Yellow with a tiny bit of Crimson Red to create an orange. Apply the flat brush with the entire tip on the page where you want to create a circle. Now, twist the brush around the center to form a circle. Repeat this motion to create three more orange circles across the canvas. Wash your brush.

STEP 4: Make a watery Crimson Red wash, then use a clean number 8 round brush to make more circles on the page (the exact number doesn't matter). When the orange circles are dry, try overlapping one of your light red circles on top of an orange one. Wash your brush.

STEP 5: Repeat step 4 using a pink color made from Crimson Red and a little bit of Cerulean Blue, filling in the remaining empty areas with circles.

STEP 6: Use a pencil to sketch some simple shapes, like clouds or stars, over the dry circles and background.

STEP 7: Mix Ivory Black paint with just enough water for it to flow. Use a number 1 rigger brush or the tip of your number 4 round brush to lightly trace the pencil sketch lines in the paint, starting at the top and focusing on one section at a time.

STEP 8: Lightly load your brush with more black paint, then gently dab the brush in a meandering line across the paper, either leaving space for the circles or working over the top of them.

STEP 9: Using the same paint and brush, fill in any remaining areas with small lines that form a circular shape, as if they are pockets of rain. Carefully dab the brush, leaving just a short brushstroke behind. When the painting is fully dry, carefully remove the masking tape around the border to finish.

TIP: The twisting-brush method in step 3 will work best with a soft, natural bristle brush. If the result is patchy, use a round brush to tidy up the circle.

Practicing Value: A Stormy Sky

Value is a scale of how light or dark a color is and creates the illusion of depth and dimension. A strong understanding of value will benefit any painting, but especially ones with high-contrast lighting. This lesson will demonstrate how to layer paint to achieve depth through value.

MATERIALS: Watercolor pad or canvas (rough cold press), masking tape, pencil, mixing palette, 2 jars of water, number 8 round brush, number 4 round brush

COLOR PALETTE: Cerulean Blue, Viridian Green, Ultramarine Blue, Cadmium Yellow

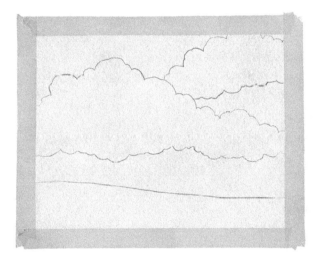

STEP 1: Begin by creating a light pencil sketch of your landscape. For this basic lesson, use a slightly curved horizon line and one or two large, fluffy clouds.

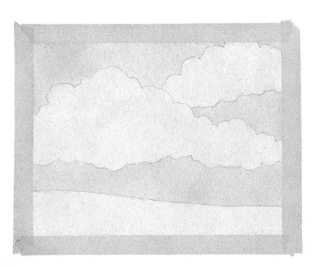

STEP 2: Load a number 8 round brush with very watery Cerulean Blue. Paint the background sky, carefully maneuvering the brush tip to get all around the bumpy cloud edges. Don't worry about washing the brush, as the next color you mix will also use Cerulean Blue.

STEP 3: Using the same brush, mix a tiny amount of Viridian Green with Cerulean Blue to create a strong turquoise. Dab the color repeatedly onto the wet paper, leaving lots of splotches of color and making the lower section of sky the darkest. Let dry and wash your brush.

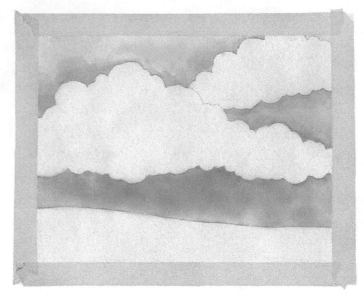

STEP 4: Cover the background with one more even layer of Cerulean Blue paint. Wash your brush.

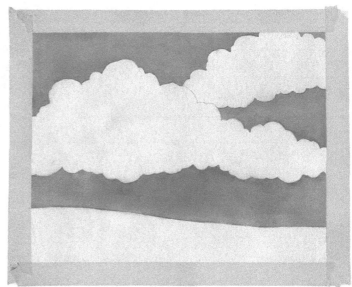

STEP 5: Mix Ultramarine Blue with a bit of Viridian Green and water to create a slightly translucent color. Use a number 4 round brush to apply the color to your first cloud. Let dry. Then, apply another layer of paint to make the shadow on the base of the cloud. The edges of the shadow should roughly match the edges of the cloud.

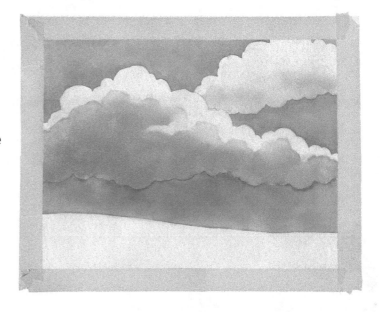

STEP 6: Repeat step 5 for the second cloud. When both clouds are dry, add another layer of the same paint with the same brush, covering the lower areas of the cloud to give a splotchy shadow effect. Bring some of this paint layer down into the sky below to soften the cloud's edge. Wash your brush.

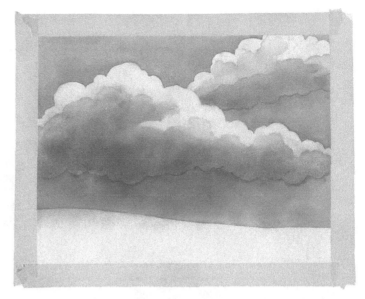

STEP 7: Mix Viridian Green with a little Cadmium Yellow and a lot of water to get a translucent wash. Using a number 4 round brush, color below the horizon line, starting at the left and adding more water to your color as you move to the right.

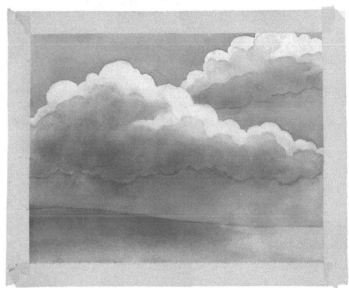

STEP 8: While the horizon is still wet, load your brush with Viridian Green and paint a darker area of shadow on the grassy ground below the cloud on the left side of the page. When the painting is fully dry, carefully remove the masking tape around the border to finish.

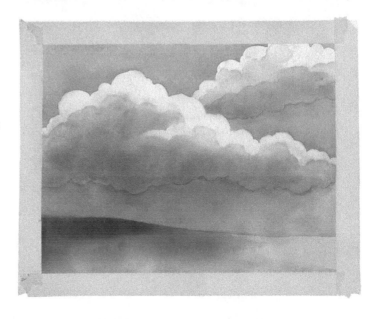

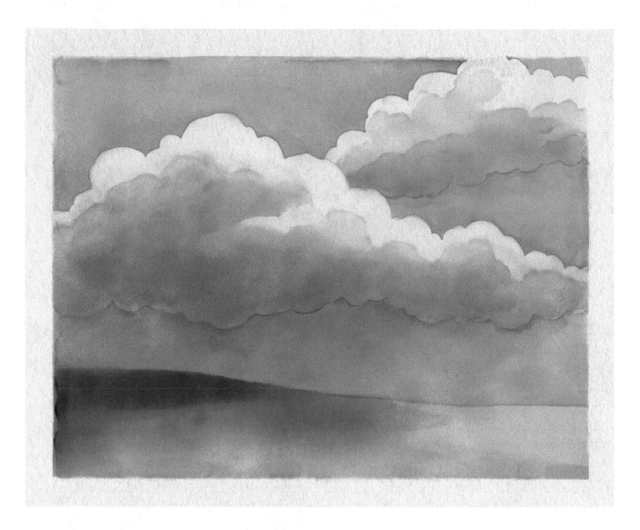

TIP: A value shift can be achieved in watercolors in several ways without mixing separate shades (as is common in other media). Layering paint of the same color or different colors will give a darker value than the base shade, especially if the colors are complementary.

Adding Texture: Fiery Foliage

Watercolor paint is an incredibly versatile medium for adding texture. In this lesson, we'll use a technique called **stippling**, which is excellent for organic textures such as leaves, sheep's wool, or even fruit skin.

MATERIALS: Watercolor pad or canvas (rough cold press), masking tape, pencil, mixing palette, 2 jars of water, 1-inch flat brush, number 4 round brush

COLOR PALETTE: Cadmium Yellow, Burnt Sienna, Ultramarine Blue, Cadmium Red

STEP 1: Using your pencil, sketch out the shape of a tree, including segments of bark on the trunk and meandering, bumpy exteriors for the leaves. The lines should give the impression of organic clusters of leaves. Make sure all lines form closed shapes, as in a paint-by-numbers piece.

STEP 2: Mix a little Cadmium Yellow with water to create a wash. Use your 1-inch flat brush to lightly paint the entire page, top to bottom, in horizontal strokes. Wash the brush when done.

STEP 3: Mix up a slightly watery Burnt Sienna and use a number 4 round brush to paint the lightest segments of the tree trunk with it. To paint the darkest segments, mix in a little Ultramarine Blue. For the bluer contrasting segments, add a little more blue and water. Wash your brush.

STEP 4: With a clean number 4 round brush, apply a flat Cadmium Yellow base to the foliage area of the tree, staying within your pencil sketch lines. Rinse the brush and set it aside while this layer dries.

STEP 5: To begin to build the leaf texture, mix a small amount of Cadmium Red with Cadmium Yellow with water until slightly translucent. Use your number 4 round brush to apply the orange, beginning with the shadowed, lower side of the foliage mass, as you did with the clouds in Lesson 4 (Value, page 29). Once you've shaded the solid area, load your brush with more orange paint and dab it gently just beyond the shadow, leaving behind small dots of color until your foliage looks like the example. Let dry.

STEP 6: Mix another orange, using a slightly higher ratio of Cadmium Red this time. Repeat step 5 with the darker orange to build up more shadow and texture. Let dry.

STEP 7: Repeat the process one final time with a watery, pure Cadmium Red applied at the very bottom edges of the foliage. You should be applying less paint with each shaded texture area.

STEP 8: For a finishing touch, add a big wet wash to the grassy area. Use an orange paint, with a few dabs of yellow to add variety to the color. When the painting is fully dry, carefully remove the masking tape around the border to finish.

TIP: For a much smaller stipple effect, use the tip of a rigger brush to add tiny dots. Try experimenting with any brushes you have to see what textures you can leave on the paper.

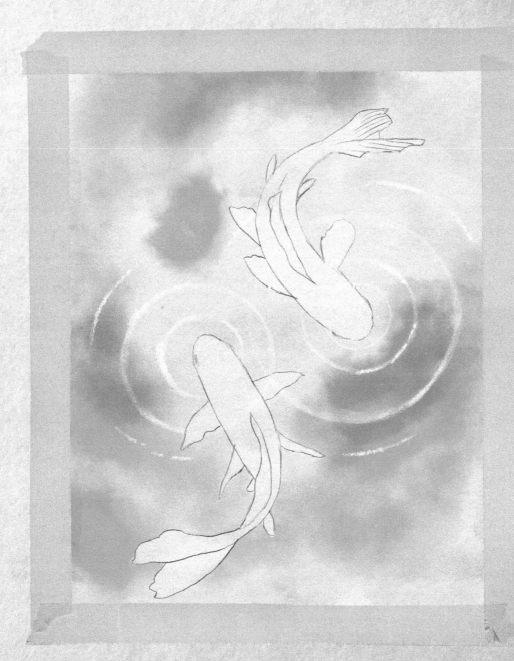

PART II

30-MINUTE
WATERCOLOR PAINTING
PROJECTS

When Life Gives You Lemons . . .

With our first project, a vibrant citrus-themed still life, you will produce a beautiful painting while evolving the skills you picked up in Lesson 2 (Shape, page 19). It will add to your basic still life tool kit, with some further layers of shading, and some more practice of wet-on-dry painting.

MATERIALS: Watercolor pad or canvas (rough cold press), masking tape, pencil, mixing palette, 2 jars of water, number 8 round brush, number 4 round brush

COLOR PALETTE: Cadmium Yellow, Crimson Red, Viridian Green, Ultramarine Blue, Ivory Black

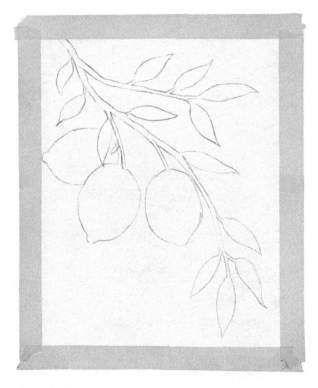

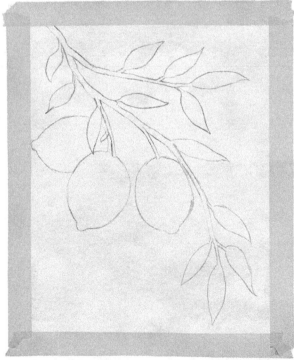

STEP 1: Begin with a light pencil sketch of a branch with lemons and leaves on it. Fill as much of the paper as you can. The larger you draw, the more space you will have to paint within the shapes.

STEP 2: Prepare your paper with a very thin wash of Cadmium Yellow paint, completely covering the paper, and then wait for it to dry. While waiting, wash your brush and set it aside.

STEP 3: Next, mix your yellow into a little water as the base color for the lemons. You'll want a stronger yellow than the one used for the background wash. Use your number 8 round brush to paint within the pencil lines, aiming for an even coverage.

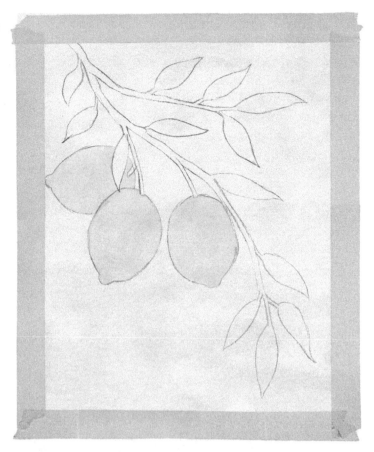

STEP 4: Mix a yellow-orange shade using Cadmium Yellow and a very small amount of Cadmium Red. Use a number 4 round brush to pick out the shadows on the side of the fruit, then use a wet brush to draw the orange further into the middle of the lemon, creating a shading effect.

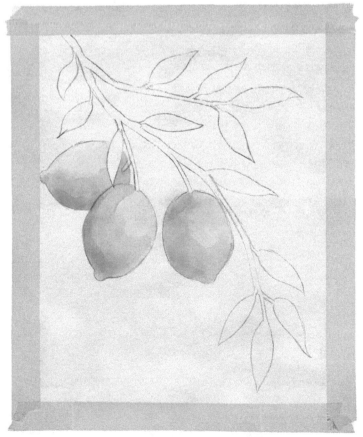

STEP 5: Mix a slightly darker orange (using more red) than the one used in the previous step, and, using your round brush, follow the curved shape of the lemons to define a second layer of shadow, giving the shading a richer depth.

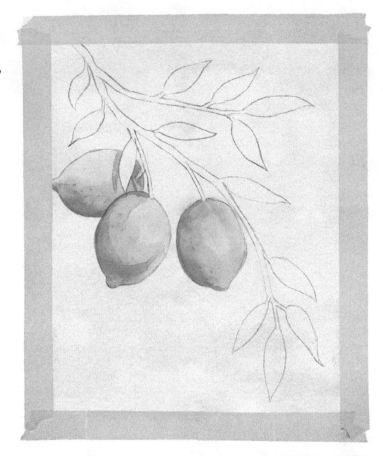

STEP 6: Use a watery Viridian Green with a number 4 round brush to color in the branch with a wet-on-dry flat wash (see page 11). Start at the top and work down to avoid smudging. Use the tip of the bristles aligned with the tip of each leaf to bring the color all the way in. Since you're painting a large area with a small brush, the area will likely be almost dry by the time you're done.

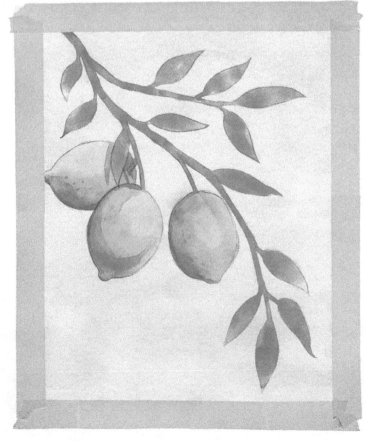

STEP 7: Mix a darker green paint by adding a little Ultramarine Blue to the Viridian Green. Use a round brush to work the dark green into the leaves, adding shadow in limited areas to the top of the leaf and fading down into the middle. Add some shadows to the stem, too.

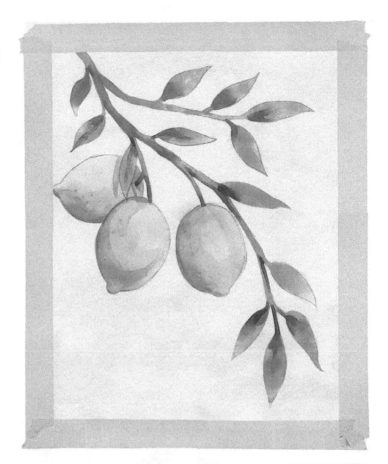

STEP 8: When the previous step has dried, add one more layer of dark Viridian Green shadow. Add a tiny bit of Ivory Black to the mix and use it over the existing shadows to add more dramatic contrast. After the artwork is dry, remove the masking tape for a clean border. Very carefully and slowly remove the masking tape, one strip at a time, starting with the last one you applied and working backward to the border. Don't use too much force or work too quickly, or you might rip the painting.

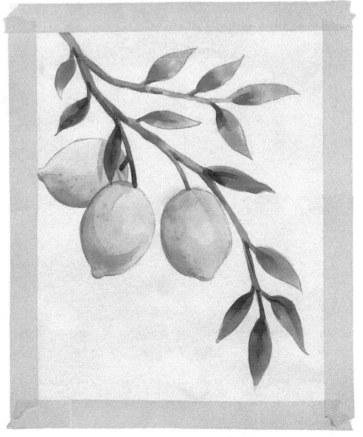

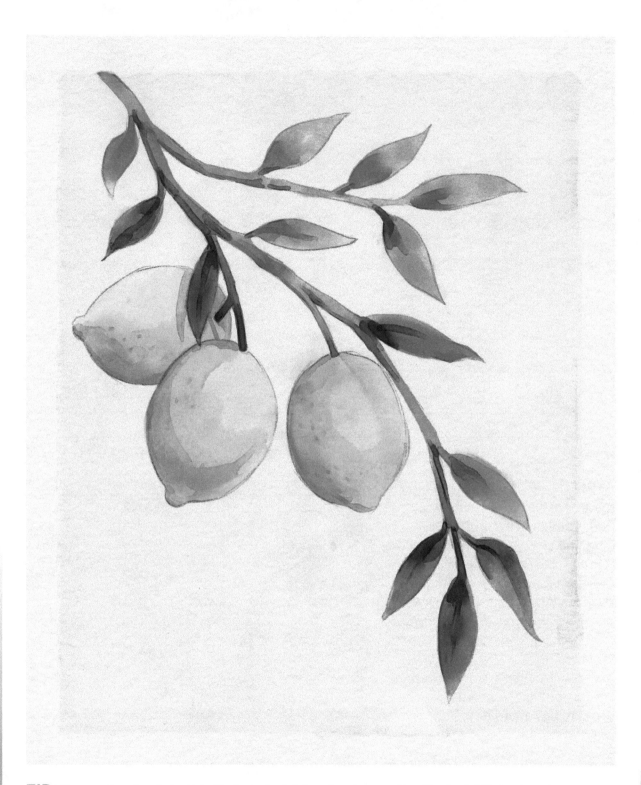

TIP: Try coming back to this first project later (perhaps after Project 10) and make an alternative version with more branches and lemons in the background. Use the skills you pick up later in the book to create an impression of depth.

Rainbow City Silhouette

Project 2 will focus on setting up a controlled area for wet-on-wet washes. You'll also evolve the skills you gained painting gradients in Lesson 1 (Color, page 14). This painting is a colorful, fun design that highlights some abstract techniques, which can be the building blocks for a variety of subjects.

MATERIALS: Watercolor pad or canvas (rough cold press), masking tape, pencil, mixing palette, 2 jars of water, 1-inch flat brush, number 4 round brush

COLOR PALETTE: Ultramarine Blue, Crimson Red, Cadmium Yellow, Viridian Green, Chinese White

STEP 1: Start with a pencil sketch of the city skyline using a ruler or the edge of a paintbrush to keep the lines straight. Keep the silhouette shapes simple and large.

STEP 2: Add a clear water wash to your paper, wetting only the area below the silhouette outline. Use a 1-inch flat brush to bring the water up into the tall buildings and towers and into the corners of each one. Proceed immediately to the next steps.

STEP 3: Mix a strong Ultramarine Blue and use a number 4 round brush to dab it onto the wet paper, starting on the left side of the skyline. Use your brush to control the flow of the paint, nudging it toward the silhouette boundary. Let the paint spread out naturally over the wash area, creating a gradient toward the bottom of the paper.

STEP 4: Mix a purple using Ultramarine Blue and Crimson Red. Use the technique laid out in Lesson 1 (Color, page 14) to transition from the blue on the left side into a purple toward the right.

STEP 5: Continue forming a rainbow gradient, using a clean brush loaded with water to re-wet the paper if it becomes too dry for colors to spread easily. Transition the purple into Crimson Red, letting the colors mix in the wash.

STEP 6: Next, clean your brush, then prepare Cadmium Yellow and add an area to the right of the end of the Crimson Red. Allow the two to mix into orange in the middle, guiding with your brush as needed, but keeping the right edge a pure yellow.

STEP 7: Mix a little bit of Cadmium Yellow with Viridian Green to create a green shade. Finish the rainbow with an area of green on the right. Wait for everything to fully dry.

STEP 8: For the finishing touches, use the tip of your number 4 round brush with undiluted Chinese White paint to add rows of windows to the buildings. After the artwork is dry, remove the masking tape for a clean border.

TIP: Rather than using white paint on top of your dried wash, you could set this painting up with masking fluid windows before you add the wash or, on a bigger canvas, cut out small strips of masking tape instead.

Snowy Forest

For this project, we are going to practice painting with value combined with the use of blurry and sharp shapes, to achieve depth (previously the focus of Lesson 4, Value, page 29). This serene, snowy forest painting will use a cool palette and kitchen salt to create a whimsical scene and texture.

MATERIALS: Watercolor pad or canvas (rough cold press), masking tape, mixing palette, 2 jars of water, 1-inch flat brush, number 8 round brush, kitchen salt, pencil or pen, number 4 round brush

COLOR PALETTE: Ultramarine Blue, Ivory Black

STEP 1: Cover the paper with a soft blue wash, using a 1-inch flat brush loaded with thin Ultramarine Blue. This layer should still be wet so that the paint blends in the next step. Wash your brush.

STEP 2: Add a tiny bit of Ivory Black to the Ultramarine Blue mixture from step 1. Use the paint to add a darker second layer of blue at the top, using a number 8 round brush, washing slightly downward around the edges and blending to create a gradient.

STEP 3: Using the same mixture as above, use this darker shade of blue to add color to the bottom, pulling it upward to form the blurry shapes of trees. Wash your brush.

STEP 4: Add a light sprinkle of salt over the top two-thirds of the painting, then wait for the paint to dry.

STEP 5: When the painting is completely dry, gently remove the salt by brushing the paper with a paper towel. Your painting should now have a new texture that serves as a starry sky.

STEP 6: Using your dark blue paint mixture again, add a second row of tree shapes, filling more of the bottom. Define the tree outlines more this time, giving the illusion of depth against the blurrier trees you painted earlier. Wash your brush, set it aside, and let the paper dry.

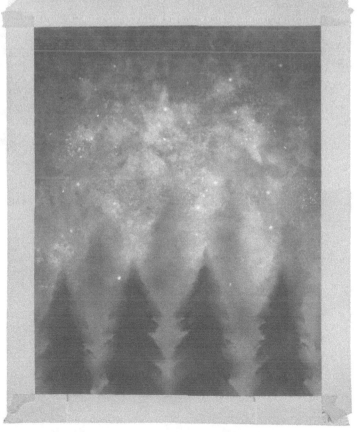

STEP 7: For the third and final row of trees, use a pencil or pen to sketch out the outline on top of the dry paint.

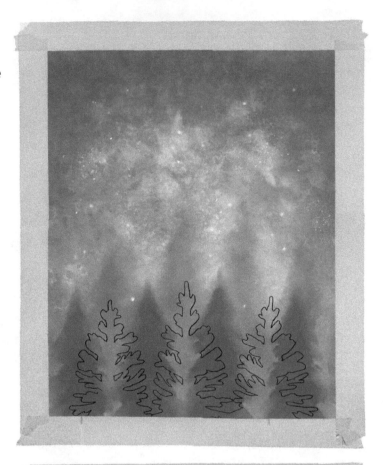

STEP 8: With a still darker shade of blue (using less water or adding in a touch of Ivory Black), fill in this last row of trees using a number 4 round brush. After the artwork is dry, remove the masking tape for a clean border.

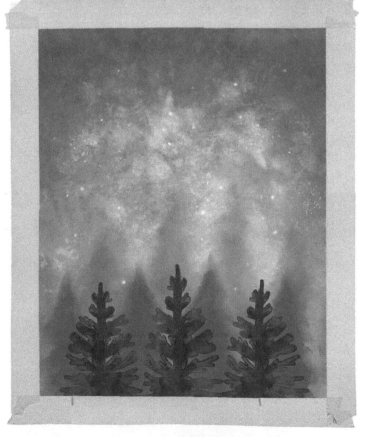

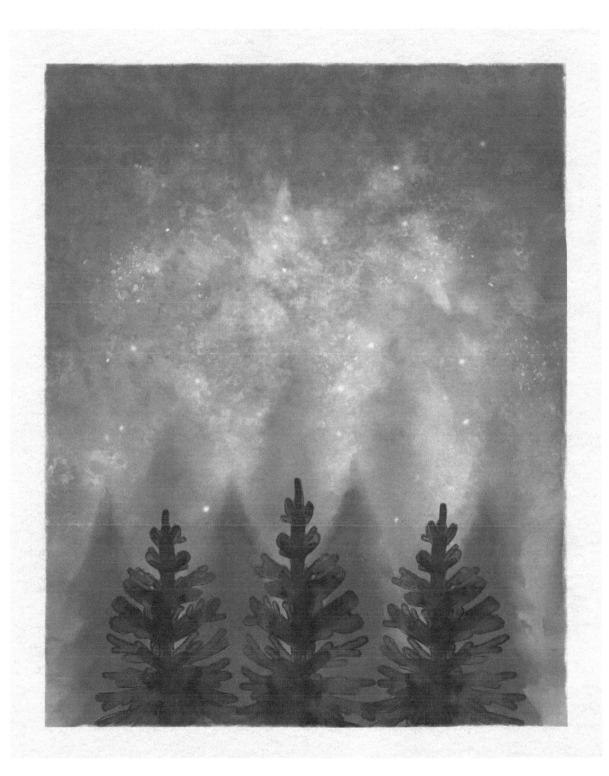

TIP: It's important to wait for a wash layer to dry before trying to sketch over the top of it, or else you might tear the paper with your pencil. However, you can use special pens to draw on top of damp watercolor paper, if you'd like to have the option.

Abstract Art

Watercolor is a perfect medium for abstract painting, where the final image can be thoughtful and beautiful even without featuring an identifiable subject. We'll use what you've learned in Lesson 1 (Color, page 14) and Project 2 (page 45), about the paint's unique interactions with water as a starting point to create a lovely abstract piece.

MATERIALS: Watercolor pad or canvas (rough cold press), masking tape, pencil, mixing palette, 2 jars of water, number 8 round brush

COLOR PALETTE: Cadmium Red, Cadmium Yellow, Crimson Red, Cerulean Blue

 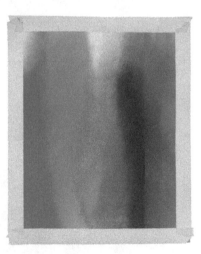

STEP 1: For abstract art, begin by thinking about what kind of mood the piece should have. Instead of pencil sketches, start by working on a separate sheet of watercolor paper and create small "thumbnail" spaces (rectangles about the size of a passport photo) to experiment with how different colors might interact, and see which one best reflects your concept. Use the thumbnail you like best as a reference. For this project, we'll be making a warm-toned piece, with a blue area on the top layers and a sharp edge on one side.

STEP 2: Lay down the base for a wet wash by completely saturating the paper with water. Start with a mix of Cadmium Red and a little Cadmium Yellow to create an orange-red. Load up your number 8 round brush and dab gently on the left-hand side, and let the orange paint spread out until it becomes faint.

STEP 3: Repeat the motion of dabbing the paint, moving the brush around a little so that the paint spreads out over the left side of the paper. Mix in a little Crimson Red as you work into the bottom left area.

STEP 4: Move over to the right side of the paper, and if the paper has dried a little, repeat the wash process, making sure the paper is wet enough for the paint to spread. Use a clean number 8 round brush to dab with a thin (watery) orange (Cadmium Red and Cadmium Yellow).

STEP 5: Repeat step 3, using the same brush, working the orange wash until it covers the right-hand third of the paper, adding a little Crimson Red at the end, toward the top right corner.

STEP 6: Wait until the paper is dry to the touch, washing your brush and setting it aside in the meantime. Take your masking tape and apply three strips of tape to cover the right-hand quarter of the paper.

STEP 7: Wet the paper with clean water over the right-hand side of the remaining visible painting, covering the area where the paper shows through, in between the red areas. Don't wait for this to dry.

STEP 8: Using a clean number 8 round brush, load up with a slightly watery (but not thinned out) Cerulean Blue, and dab it onto your paper at the bottom right corner of the exposed paper. Bring the blue up the paper, letting it flow naturally out into the wet area of the canvas.

STEP 9: Wait for the painting to completely dry. The colors may change slightly as it dries, becoming lighter or mixing a little to become less vibrant. Remove the tape on the right side and around the edges for a clean border.

TIP: Abstract painting is a wonderful playground for experimentation. Try bringing some other techniques covered in other projects into your abstract painting, such as wax crayon resist (see Project 12, page 92), masking fluid, or dry texture painting (see Project 15, page 106).

Tulip Vase

The aim of this project is to work a little more loosely and experiment with some expressive brush gestures. Between the translucent vase and the brilliant flowers, this project will build on the shape painting skills of Lesson 2 (Shape, page 19) and Project 1 (page 40).

MATERIALS: Watercolor pad or canvas (rough cold press), masking tape, pencil, mixing palette, 2 jars of water, masking fluid, number 8 round brush, number 4 round brush

COLOR PALETTE: Lemon Yellow, Viridian Green, Crimson Red, Cadmium Yellow, Ultramarine Blue, Cerulean Blue

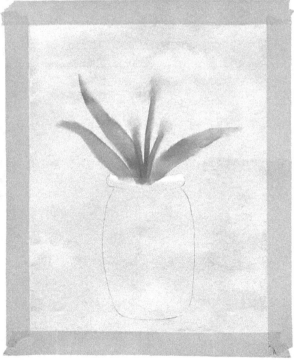

STEP 1: Begin with your pencil sketch. For this painting, sketch just the vase, not the flowers. The vase should stretch from the middle of the page to the bottom. After sketching, add an area of masking fluid to the top of the vase lip and wait for it to dry.

STEP 2: Mix Lemon Yellow with Viridian Green. Load up a number 8 round brush and press the bristles gently over the masking fluid area, sweeping upward to create three thin leaves. Use less pressure toward the end of the leaves to create a sharp point. Use a number 4 round brush to make three thin stems in the middle. Wash your brush.

STEP 3: Wet your number 8 round brush and load it with a vibrant Crimson Red mixture. Start at the tip of one of the stems and work in small circular motions to create the tulip flower. Use the gradual release of brush pressure you practiced on the leaves to create a pointed tip of the flower. Repeat this (fully washing your brush in between flowers) using Cadmium Yellow, and then purple (Crimson Red and Ultramarine Blue) paint for the other two flower heads. When the green paint is dry, remove the masking fluid.

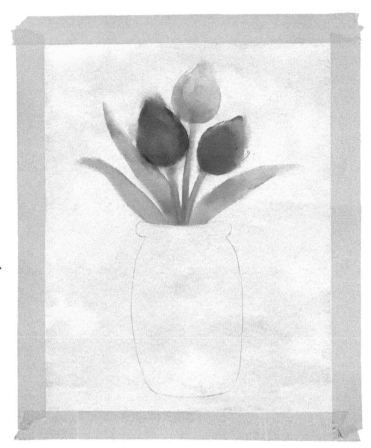

STEP 4: Use a number 8 round brush and thin (watery) Cerulean Blue paint to fill in the vase. Use a little more water in the middle to create a shadow effect at the edges.

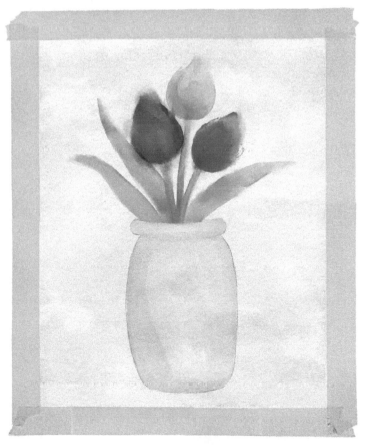

STEP 5: While the paint is still **wet**, use the same green shade from the leaves and stems and bring it down into the vase, letting it mix and blur with the water.

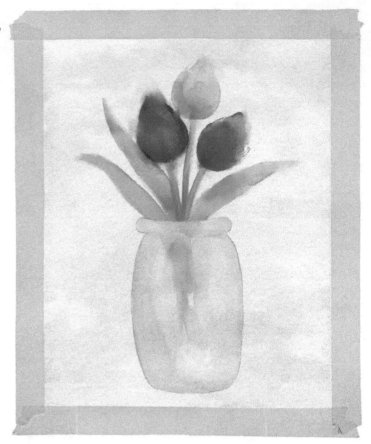

STEP 6: Use a number 4 round brush and a darker shade of blue **to** add tighter shadows to the vase **rim** and left side, as well as to define **an** area of shadow that is cast onto **the** surface below the vase.

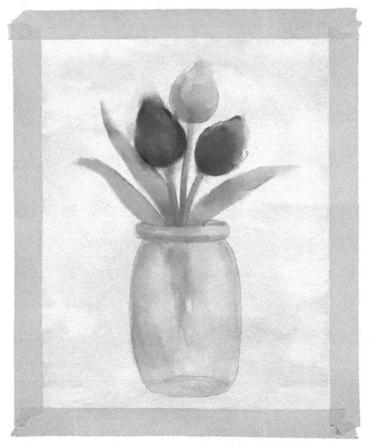

STEP 7: Wait for the vase to dry (otherwise it will be difficult to get a hard edge against the background), and then use a large flat brush to apply a deep Cerulean Blue wash to the bottom left corner, fading upward. Leave a thin strip of blank white background at the bottom to suggest the table surface.

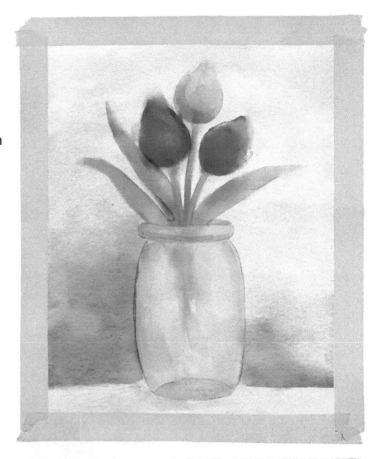

STEP 8: Add the final touches of shadow to the flowers, using the dark blue paint from the background and a number 4 round brush. Pick out some areas to shade on the leaves, such as at the base or along the centerline, and beneath the tulip flower heads. After the artwork is dry, remove the masking tape for a clean border.

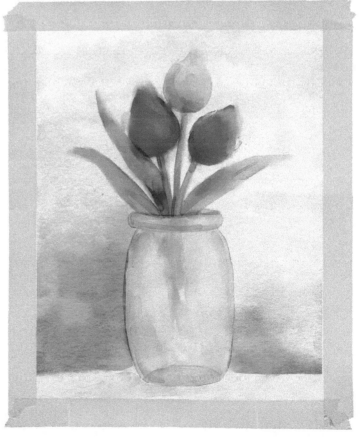

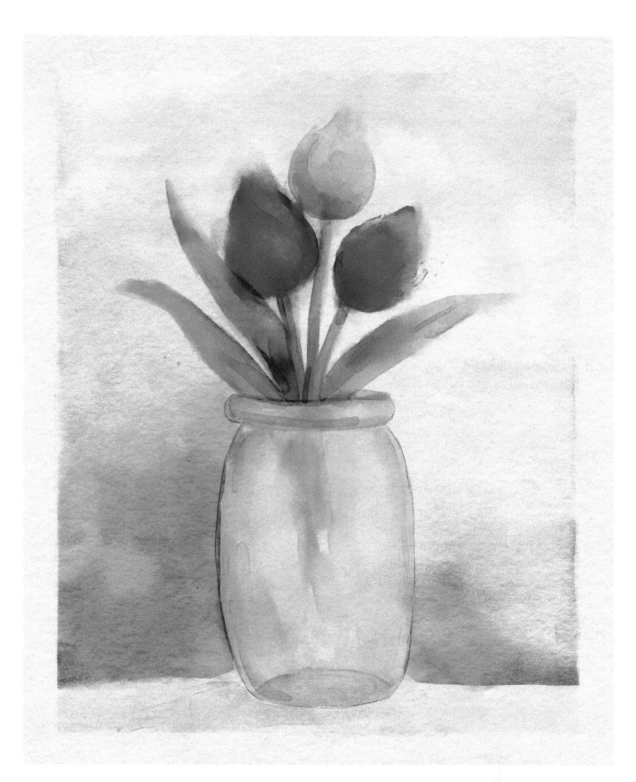

TIP: Try experimenting: Use your brushes without a pencil sketch, start with the flowers and add the stems and leaves afterward, or paint a bundle of flowers without the vase. This will help you get a sense for how certain movements or levels of pressure leave marks on the paper.

Fluffy Feathers

Project 6 will advance your brush control and show you how to add texture to a wash by adding fine details over wet and dry paint, including reshaping the edge of a wash. The focus of the painting is three differently shaped feathers, the perfect subject for very fine, detailed textures, which builds upon the large-wash and smaller-detail skills from Projects 1 and 5 (pages 40 and 60). You'll also have the opportunity to practice with the rigger brush.

MATERIALS: Watercolor pad or canvas (rough cold press), masking tape, pencil, mixing palette, 2 jars of water, masking fluid, number 8 round brush, number 1 rigger brush, number 4 round brush

COLOR PALETTE: Crimson Red, Ultramarine Blue, Cerulean Blue, Viridian Green, Lemon Yellow, Cadmium Red, Cadmium Yellow

STEP 1: Very lightly sketch three unique feather shapes. The middle feather should be a peacock feather. Use masking fluid to add some dotty patterns to the outer two feathers, and let the masking fluid dry.

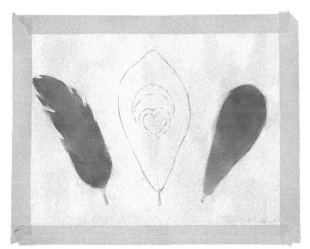

STEP 2: Paint the left and right feathers with a pink (a thin Crimson Red with a little Ultramarine Blue) and purple (similar to pink but double the amount of Ultramarine Blue) respectively using a number 8 round brush. For the left feather, taper your brushstrokes toward the top to create the uneven edges.

STEP 3: While the right feather is still wet, use a wet number 1 rigger brush to draw the paint outward, away from the base of the feather, in quick, thin strokes. This should create the fluffy, downy barb segment at the bottom.

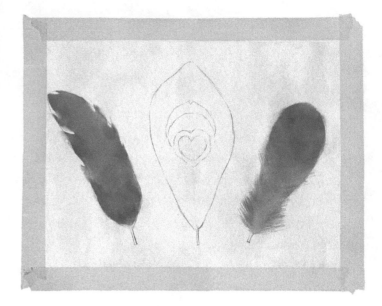

STEP 4: Paint the middle feather with a variegated wash (page 13) of Cerulean Blue and Viridian Green. Again, use the rigger brush at the edges to create the downy barbs. Wash the brush and let dry.

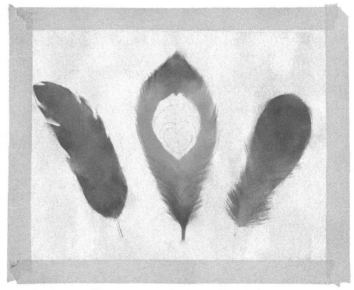

STEP 5: Fill in the middle of the peacock feather. Start by using the tip of your number 4 round brush with a little bit of lime green (Lemon Yellow and a tiny bit of Viridian Green) at the top. Wash the brush and use a watery Cerulean Blue for the outer ring of the heart shape, followed by a strong Ultramarine Blue for the center heart. Wash your brush again, wait for the green and blue to dry, and then finish with the orange (Cadmium Red and Cadmium Yellow).

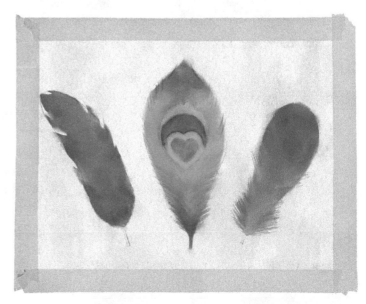

STEP 6: Create a darker pink and a darker purple color using the same process as step 2, but with less water. Use a number 4 round brush to add a darker pink line to the middle of the left feather and a darker purple line to the right feather.

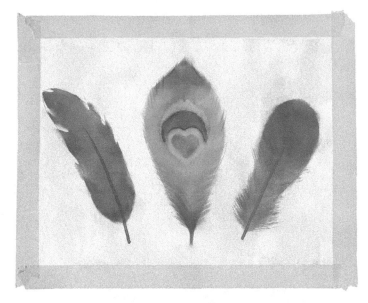

STEP 7: Mix some more watery purple paint and use a number 4 round brush to add some further pattern onto the left feather, including fine lines for texture and splotches of shadow variation. Wait for everything to dry.

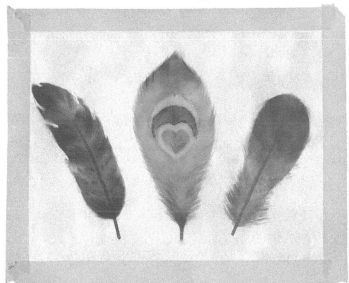

STEP 8: To finish this painting, use your number 8 round brush to wet the blank areas of paper and add a multicolor wash around the space. Pick colors from the palette you've already used, such as pink, purple, blue, and green (refer to the previous steps if you don't have any left over). Create a gradient with the colors so that they fade toward the feathers and give them a slight glowing effect. After the artwork is dry, gently remove the masking fluid areas, and then remove the masking tape for a clean border.

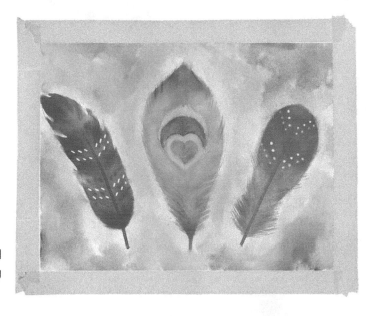

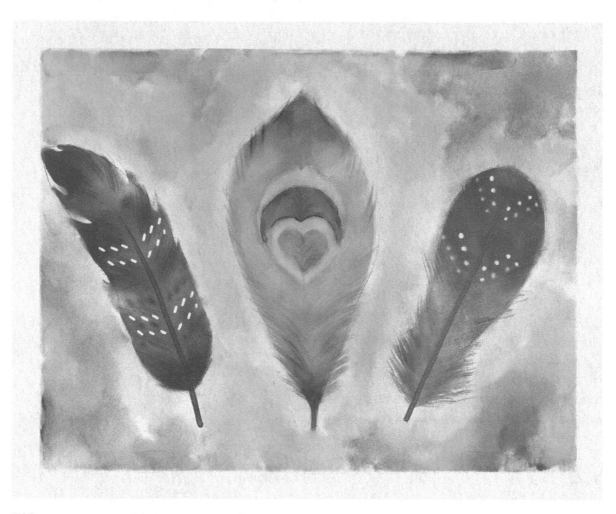

TIP: The trick to creating fluffy feathers or fur is to use short, sharp flicks of your brush to create each "spine." Get into a rhythm and it becomes therapeutic—try practicing using your rigger brush on scrap pieces of paper.

Curious Cat

Project 7 is our first foray into painting animals, though it takes an abstract approach, partly building on the expressive style of Project 5 (page 60) and using the fine detail skills from Projects 1 and 6 (pages 40 and 65). The key point here is using details to convey the essential form within an otherwise very loose painting. Fortunately, cats have the perfect mesmerizing little faces to highlight that concept!

MATERIALS: Watercolor pad or canvas (rough cold press), masking tape, pencil, mixing palette, 2 jars of water, masking fluid, number 8 round brush, number 4 round brush, number 1 rigger brush

COLOR PALETTE: Lemon Yellow, Viridian Green, Crimson Red, Ultramarine Blue, Cerulean Blue

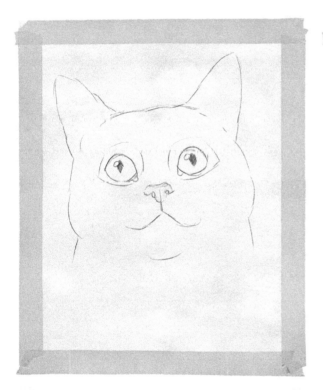

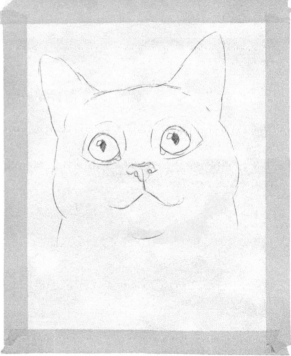

STEP 1: Start with a pencil sketch, paying close attention to the position of the eyes, nose, and mouth. The outline toward the bottom of the page can fade away. Use two small dots of masking fluid to add the highlight to the eyes. Let the masking fluid completely dry.

STEP 2: Using the Lemon Yellow paint, begin to add loose color to the lower right edge of the face, plus a few small highlights by the eyes and mouth.

STEP 3: Mix some lime green (Lemon Yellow and Viridian Green) and, using a number 8 round brush, paint some green at the base of the neck, fill in the eyes, and add some dimension by putting some green above and to the left of the left eye.

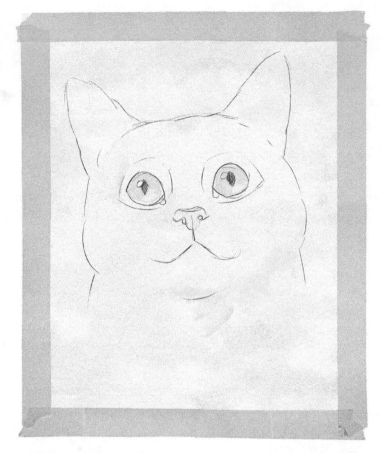

STEP 4: Mix a thin Crimson Red, and, using a number 4 round brush, paint the nose. Then, use the same red to define the tips and sides of the ears, as well as some small edges of the face.

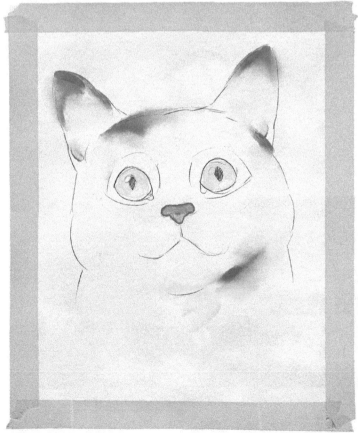

STEP 5: Mix Crimson Red with Ultramarine Blue to create a strong purple. Then, use a number 4 round brush to paint and define the cat's stripes.

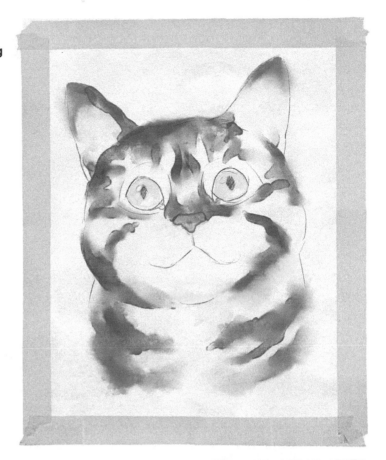

STEP 6: Using the same purple, with a number 4 round brush, define the details in the cat's facial features, including the border of the eyes, the pupils, the mouth, and the whisker dots. Wait for everything to dry.

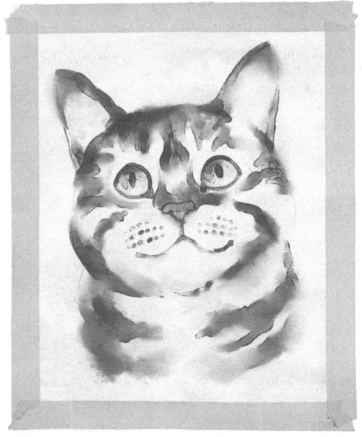

STEP 7: Mix Cerulean Blue with a lot of water and use a number 4 round brush to paint areas of shadow around the face, focusing on the inner ear, cheeks, forehead, and edges of the neck, avoiding the eyes and mouth.

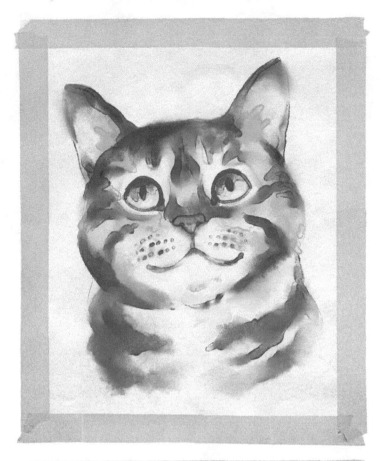

STEP 8: With your number 1 rigger brush and some of the blue paint, create the whiskers by swiftly dragging the brush lightly against the paper, outward from the whisker dots and away from the face. Finally, remove the masking fluid from the eyes to reveal the highlights. After the artwork is dry, remove the masking tape for a clean border.

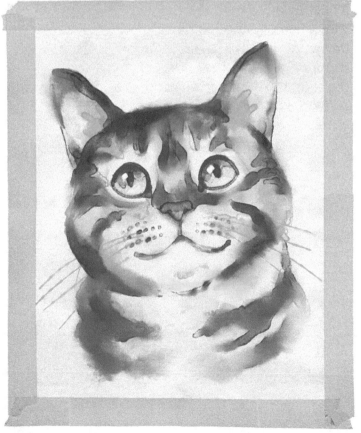

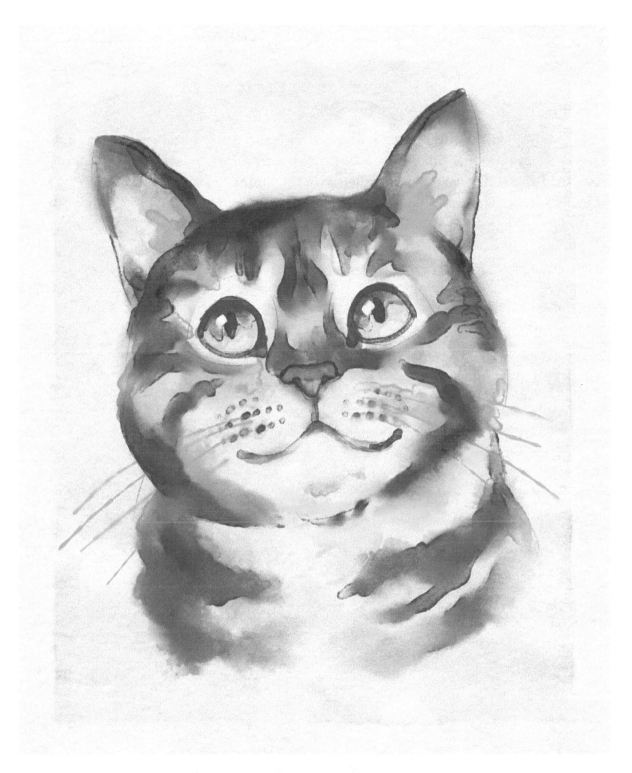

TIP: This abstract style might seem a bit surreal, but adding color in unexpected places can add an extra spark to your paintings. Try painting other realistic subjects with rainbow colors to see what you like.

Prickly Pinecone

This painting will continue your practice with brush control and creating complex, layered shadow values, including contrast between soft shapes and sharp lines. As with Project 6 (page 65), this project will test your skills in making long, thin texture effects. The subject matter will feel familiar yet more advanced compared to Project 1 (page 40).

MATERIALS: Watercolor pad or canvas (rough cold press), masking tape, pencil, mixing palette, 2 jars of water, number 8 round brush, number 1 rigger brush, number 4 round brush

COLOR PALETTE: Cadmium Yellow, Viridian Green, Burnt Sienna, Yellow Ochre, Burnt Umber, Ultramarine Blue, Ivory Black

STEP 1: Start with a pencil sketch of your pinecone, with the tip nestled in the upper left corner, so that there is room for the branch below it.

STEP 2: Use your number 8 round brush to add a watery splotch of green paint (mix Cadmium Yellow and Viridian Green for a light shade) below the pinecone, with some space in between its base and the splotch.

STEP 3: Use a number 1 rigger brush or the tip of your number 4 round brush and the same technique you practiced in Projects 6 and 7 (pages 65 and 69), sweep out Viridian Green paint from the watery splotch, creating a starburst effect.

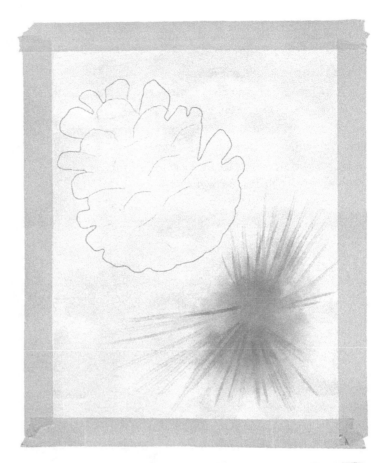

STEP 4: Using a number 4 round brush, fill the pinecone with a wet-on-dry flat wash using a mix of Burnt Sienna and Yellow Ochre. Make sure to paint carefully and slowly around the edges. Wait for this to dry.

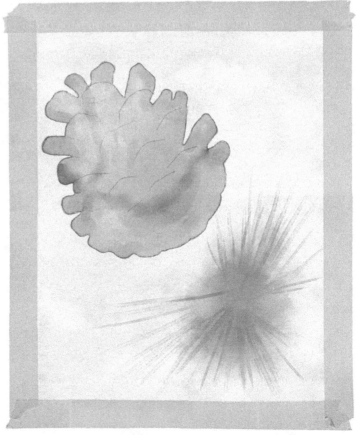

STEP 5: Use a number 4 round brush to add the first layer of shadow with a watery Burnt Sienna, leaving gaps for the irregular shapes, which will be the tips of the pinecone's points. Start from the middle, and then add a little water to your brush as you bring the paint out toward the edges.

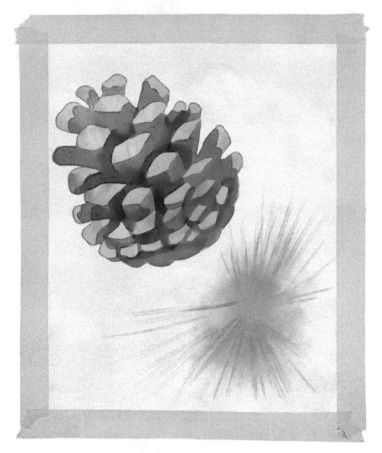

STEP 6: After step 5 has dried, use the same brush and a slightly darker brown (add a little Ultramarine Blue) to add the second layer of shadow. This should be filled into the crevices and on one side of each point, with more detail toward the bottom of the cone to show shadow.

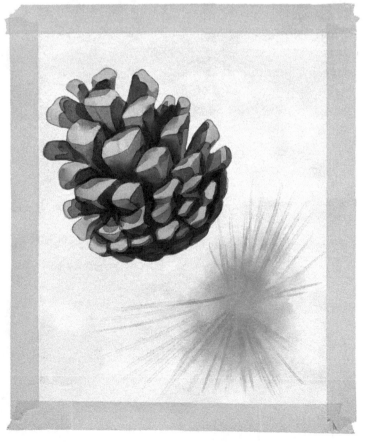

STEP 7: Load your number 4 round brush with a thin (watery) Burnt Sienna mixture. Paint a branch for the pinecone to be hanging from which intersects with the pine needle splotch you made previously. Add two more branches stretching in other directions.

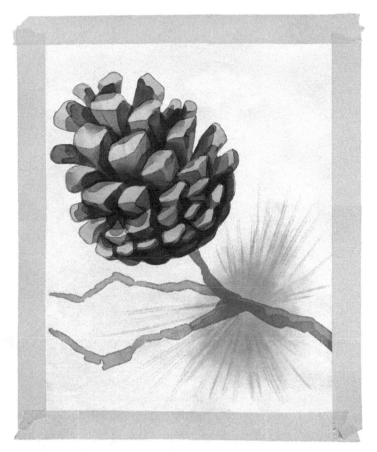

STEP 8: Mix your Burnt Sienna with Ivory Black and paint shadows onto the lower left edges of the branches. Dot it gently along the branches to give it some slight texture. After the artwork is dry, remove the masking tape for a clean border.

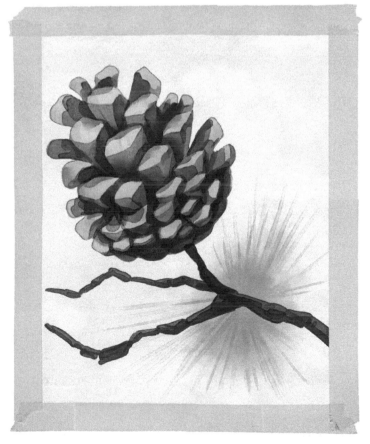

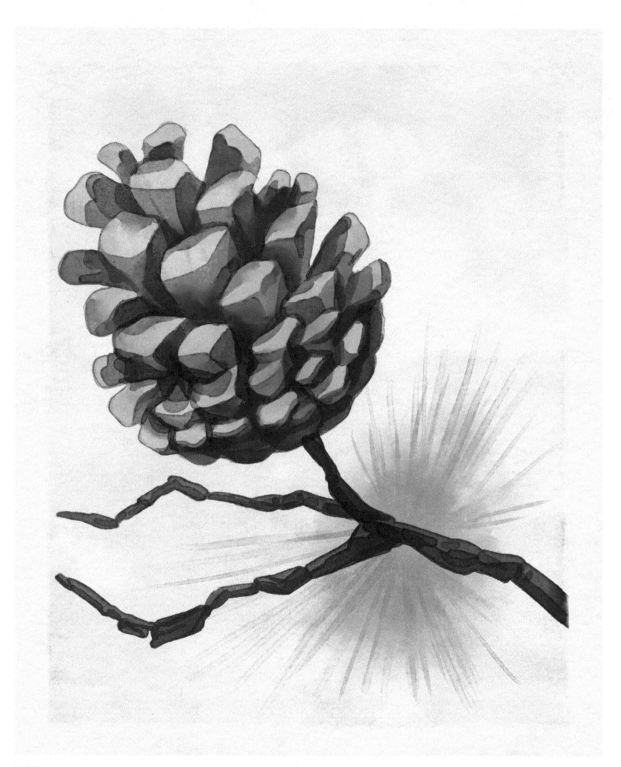

TIP: While painting a pinecone from the side is most common, try painting one from the top or bottom and see how it turns out.

Blue Jay

Project 9 acts as a checkpoint, combining all the skills we've covered so far to paint a charming blue jay. This project puts particular emphasis on layering small segments to build dimension and depth in producing a realistic animal painting.

MATERIALS: Watercolor pad or canvas (rough cold press), masking tape, pencil, mixing palette, 2 jars of water, number 8 round brush, masking fluid OR white wax crayon, number 4 round brush

COLOR PALETTE: Ultramarine Blue, Crimson Red, Cerulean Blue, Ivory Black, Yellow Ochre

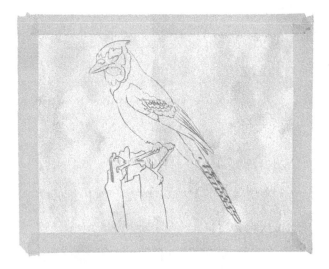

STEP 1: Start with a detailed bird sketch. Precision is key here. Use a photograph for reference or copy the project art as closely as you can. Defining the details in the face and wing will help give you clear shapes to paint in later steps.

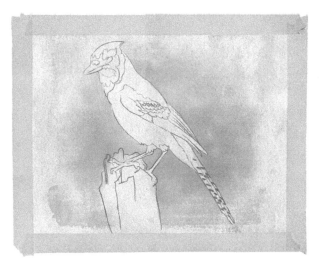

STEP 2: Use a variegated wash of watery Ultramarine Blue and light Crimson Red to create a background behind the blue jay, being careful not to cross the pencil sketch onto the bird's body.

STEP 3: Add some masking fluid sections above the eye and on the wing, as shown. If you don't have masking fluid, you could use a white wax crayon (see Project 12 on page 92 for full demonstration). Let the masking fluid dry completely.

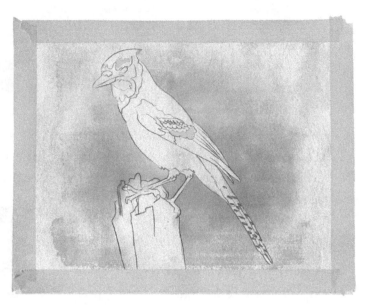

STEP 4: Using a number 4 round brush, paint the main area of feathers with Cerulean Blue, adding a little bit more water toward the bottom tip of the wing to give the impression of a highlight.

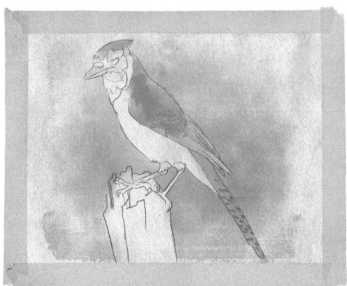

STEP 5: Add a bit of Ultramarine Blue to your watery Cerulean Blue paint. Use this darker blue and your smallest round brush or number 4 round brush to pick out the details around the face, beak, wing, and tail, as shown.

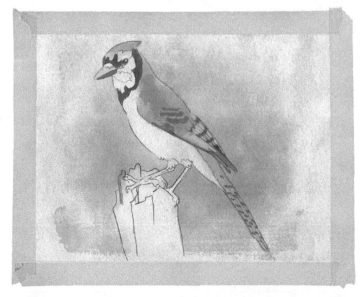

STEP 6: Use a very watery Ivory Black and the tip of your number 4 round brush to add gray patches of shadow beneath the bird's chin and on its chest and back leg.

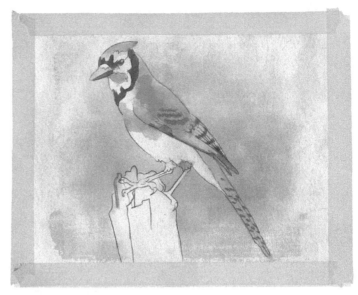

STEP 7: After the paint on the bird's body is dry, use the darker blue from step 5 again and the tip of the number 4 round brush to shade the legs and add another shadow layer over the bird's body, particularly areas like under the wing, on the white feathers at the top of the legs, and on the under-side of the face. Use the same brush (wash first) to apply a thick Cerulean Blue to the top section of the beak.

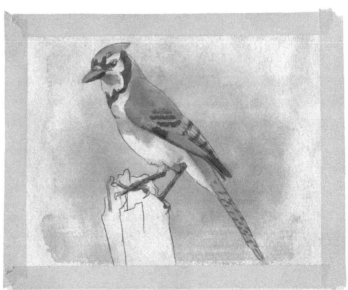

STEP 8: Fill in the wooden perch with the shadow-layering technique practiced in Project 8 (page 74) to create a three-dimensional effect, using Cerulean Blue and adding a tiny bit of Yellow Ochre for the darker strokes on top. Then, once the paint is dry, remove the masking fluid, revealing the white highlights. Remove the masking tape for a clean border.

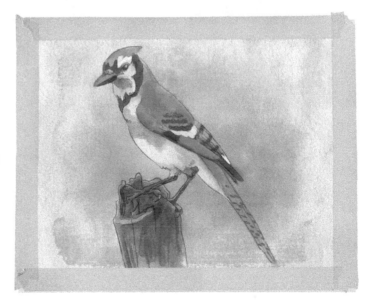

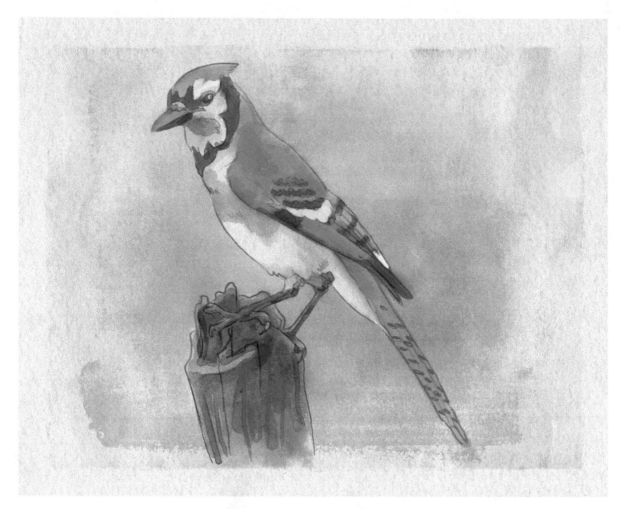

TIP: Your smaller brushes are especially easy to accidentally warp, so always make sure to put them down flat on a surface and don't leave them sitting in a jar of water—not even for a five-minute break!

Sunflower Field

This project builds on Lesson 4 (Value, page 29), and Projects 5 and 8 (pages 60 and 74). It will involve further practice illustrating depth using a sharp foreground with dark tones, graduating into a lighter, less-defined background.

MATERIALS: Watercolor pad or canvas (rough cold press), masking tape, pencil, mixing palette, 2 jars of water, number 8 round brush, number 4 round brush, 1-inch flat brush

COLOR PALETTE: Cadmium Yellow, Burnt Sienna, Burnt Umber, Viridian Green, Cerulean Blue, Ivory Black, Chinese White

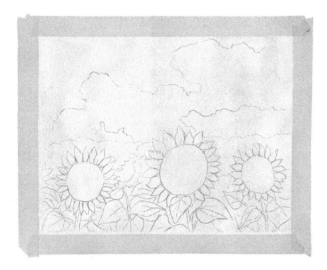

STEP 1: Lightly sketch the foreground sunflowers, the horizon line of the field, and the clouds.

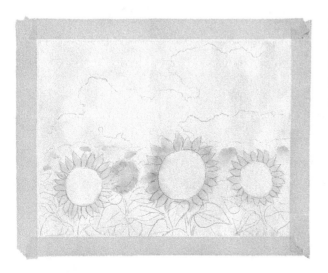

STEP 2: Use Cadmium Yellow and a number 8 round brush to fill in the sunflower leaves and add a few more splotches in the background. It's okay to be a little messy here.

STEP 3: Use a number 4 round brush to apply a slightly variegated wash (page 13) to fill in the sunflower centers, from Burnt Sienna (outside) to Burnt Umber (inside).

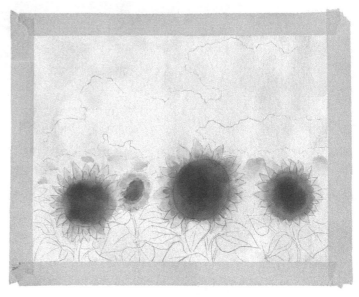

STEP 4: Load a 1-inch flat brush with a thin green (Cadmium Yellow and Viridian Green) mixture and apply it around the yellow sunflower petals. Use the straight tip of the bristles to work around the negative space around the pointy petals. Swap to a number 4 round brush for any tight spaces between flowers.

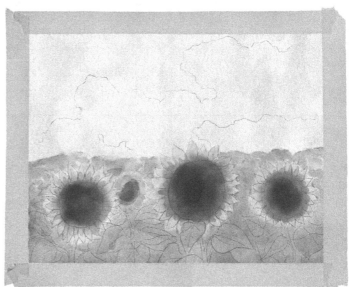

STEP 5: After the previous wash has dried a little, use a number 4 round brush with Viridian Green to fill in the negative space around the sunflower leaves. (This means painting around the front-most leaves and stems.)

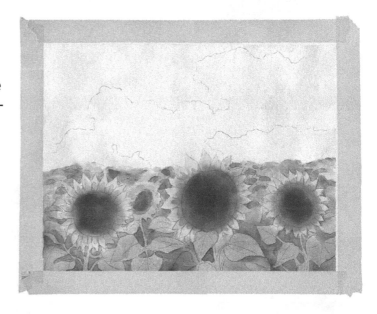

STEP 6: Use another layer of Viridian Green shadow, this time with a little bit more water, to pick out the areas of shadow that would be cast on the leaves by the surrounding flowers.

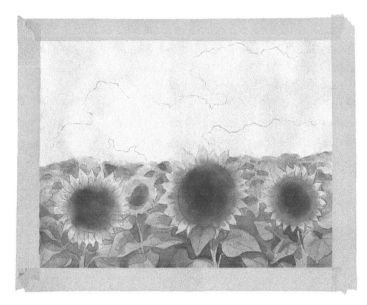

STEP 7: Use a mixture of Viridian Green and Burnt Sienna and a number 4 round brush to add the darkest details: the sunflower seeds and the veins on the foremost leaves.

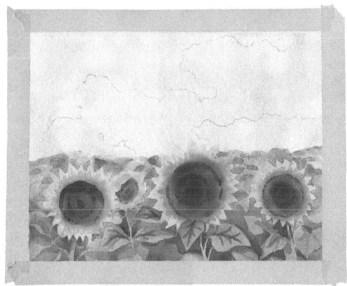

STEP 8: Wash your brush. Use Cerulean Blue and a large round brush to add a soft wash of blue sky around the clouds in the background, being careful not to bleed past the horizon.

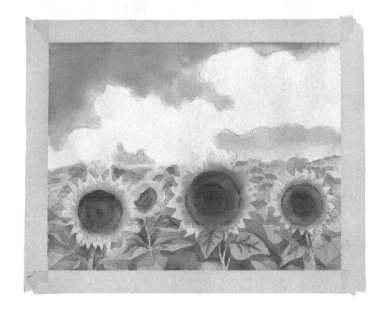

STEP 9: Using the same brush and a gray paint mix of Ivory Black and Chinese White, add the dark underbelly to the clouds, layering it darker at the bottommost edges. After the artwork is dry, remove the masking tape for a clean border.

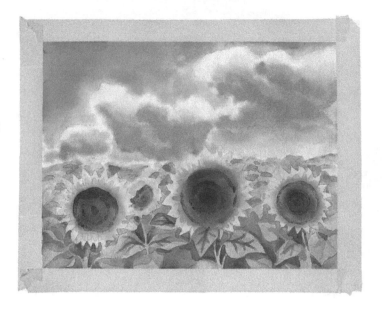

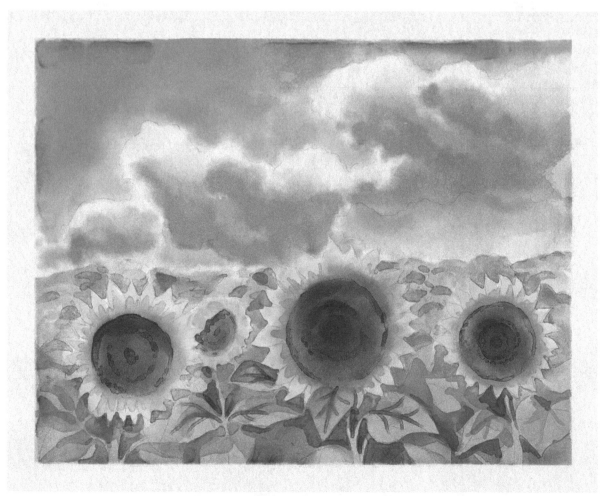

TIP: Negative space is important when painting cluttered scenes; a strong border can pick out a subject that would otherwise be lost among the similar colors and shapes around it.

Fab Frenchie

This project will focus on using your well-practiced brush control to flow between shapes, using a contrast of sharp-edged detail with soft wash shading, building a sense of physical mass and defining a subject. And who can resist a cute puppy?

MATERIALS: Watercolor pad or canvas (rough cold press), masking tape, pencil, mixing palette, 2 jars of water, masking fluid, number 8 round brush, number 4 round brush

COLOR PALETTE: Yellow Ochre, Burnt Sienna, Crimson Red, Ivory Black

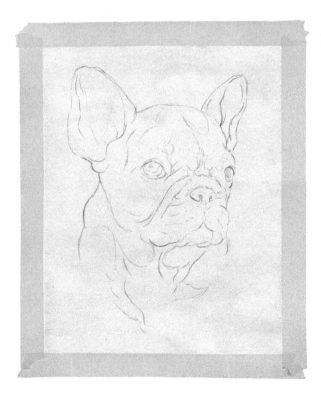

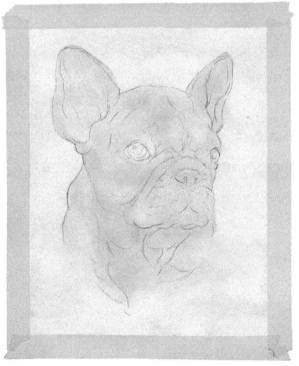

STEP 1: Sketch your subject. You'll want to include a lot of detail in the sketch, to act as guiding lines for your brush direction. Add two dots of masking fluid for the eyes, too. Wait for the masking fluid to dry. Then cover the whole paper in a thin Yellow Ochre wash using a number 8 round brush and wait for it to dry.

STEP 2: Add another layer of thin Yellow Ochre wash over just the dog, fading out in a V shape toward the bottom edge.

STEP 3: Use a thin (watery) preparation of Burnt Sienna and your number 8 round brush to color in the muzzle area, inside the ears, and around the eyes. Wash the brush and wait for this to dry.

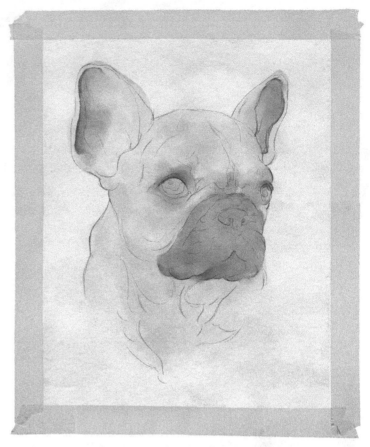

STEP 4: Using a slightly opaque mix of Yellow Ochre and a number 8 round brush, follow the curved inside edges of the lines you sketched, letting each stroke fade out as you finish it.

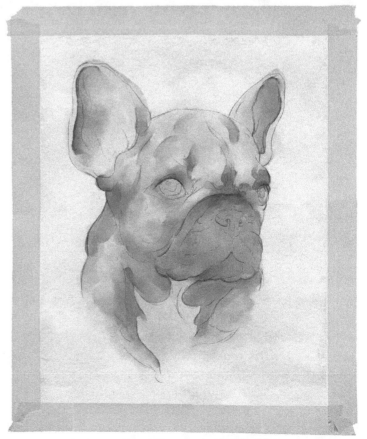

STEP 5: Use a very thin Crimson Red and number 4 round brush to add a pinkish tone inside the ears, around the mouth, and under the jaw. Wash your brush.

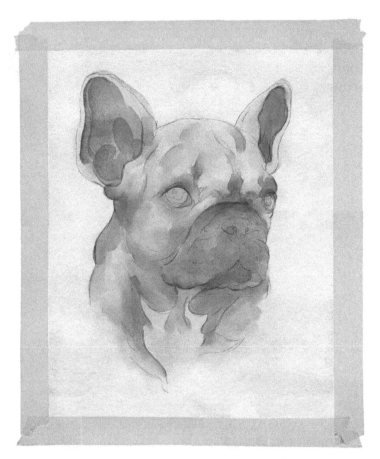

STEP 6: Use Ivory Black and the same brush to carefully add some darker features to the dog's face, including the center of the eyes, upper eyelid, and nose. Wait for everything to dry.

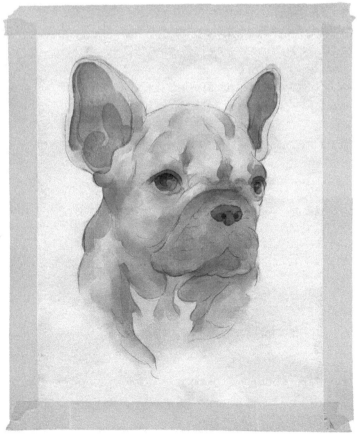

STEP 7: Use the watered-down Ivory Black with a number 4 round brush to add some more definition around the muzzle, eyes, and ears.

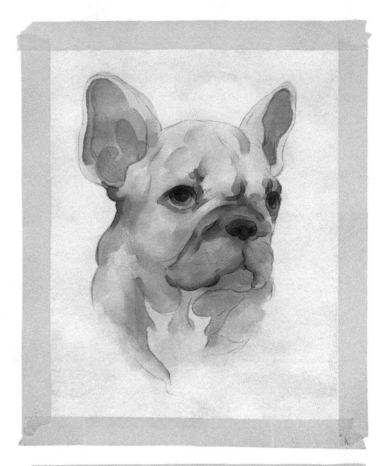

STEP 8: Finish the painting with a little more Ivory Black definition, adding texture with whisker spots, lowlights at the base of the ears, and further shading around the muzzle and eye sockets. After the artwork is dry, remove the masking fluid to reveal the eye highlights, and remove the masking tape for a clean border.

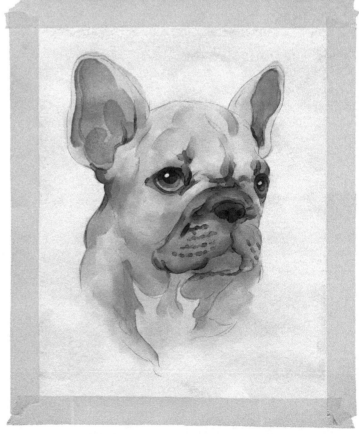

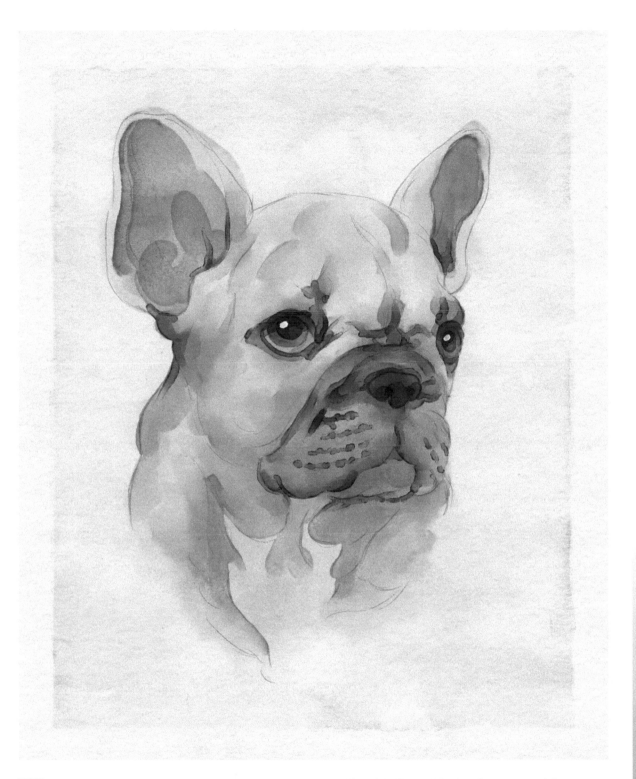

TIP: Once you can start to see complex creatures like this Frenchie in shapes and lines, you can use the same approach with any living thing. Use reference photos for this project and others to help you capture important details.

Peaceful Pond

This project uses a new technique: the wax crayon resist. The wax repels water-based paint, giving a similar effect to masking fluid. However, it can be used in a much larger area more easily and is *not* removable, so it must be wielded with care.

MATERIALS: Watercolor pad or canvas (rough cold press), masking tape, mixing palette, 2 jars of water, pencil, white wax crayon, 1-inch flat brush, number 8 round brush, number 4 round brush

COLOR PALETTE: Cerulean Blue, Viridian Green, Cadmium Red, Cadmium Yellow, Ultramarine Blue, Crimson Red

STEP 1: Begin with a pencil sketch of the two fish. Place them so that they are filling most of the page vertically.

STEP 2: Use your white wax crayon to draw rings around the heads of the fish, giving the impression they might be touching the surface. (The example art has been darkened to show the wax circle placement.)

STEP 3: Prepare the paper around the fish for a wet-on-wet wash (page 11), using a 1-inch flat brush to heavily saturate the paper with clean water. Use a number 8 round brush to carefully drop and dab watery Cerulean Blue and Viridian Green onto the wash area, taking care not to paint past the fishes' edges.

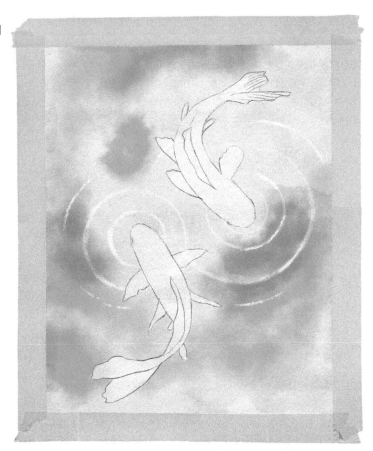

STEP 4: Fill in the entire paper around the fish with the blue and green hues, switching between the number 8 round brush and number 4 round brush depending on the size of the area. Let the paper dry.

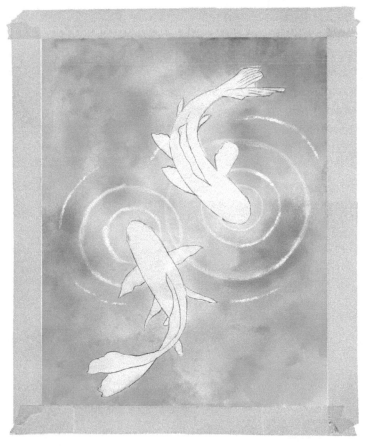

STEP 5: Use a number 4 round brush and a mix of Cadmium Red and a little bit of Cadmium Yellow to add the splotchy patterns to the fishes' main bodies. Wait for these areas to dry.

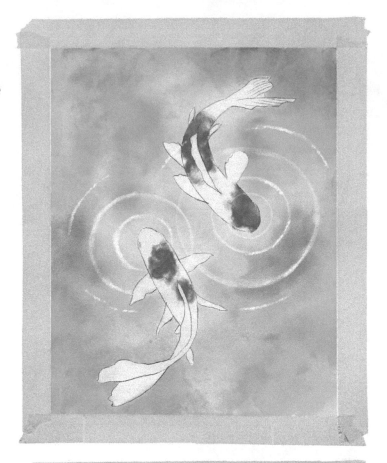

STEP 6: Use a thin layer of Ultramarine Blue and a number 4 round brush to shade the fish, making sure to keep the light source consistent (in the example, it's coming from the right). Fade your shadows toward the front of the fish for a blurry effect.

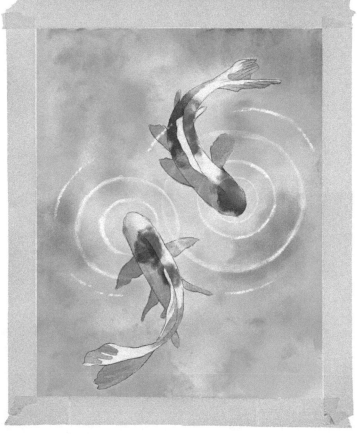

STEP 7: Mix a little Crimson Red with the Ultramarine Blue from the last step and use this new mixture with a number 4 round brush to add one more layer of shadow, picking out the edges of the fins.

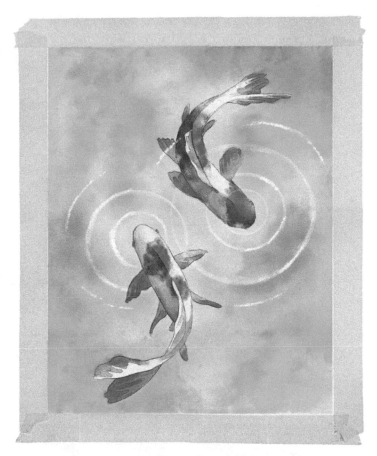

STEP 8: Take the leftover paint from step 7 and water it down a little more, then use it to add a bit of shadow around the ripples in the water to give them a three-dimensional effect. After the artwork is dry, remove the masking tape for a clean border.

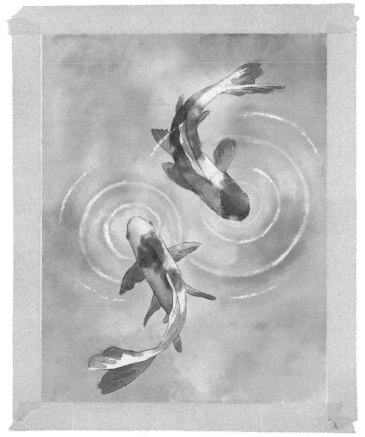

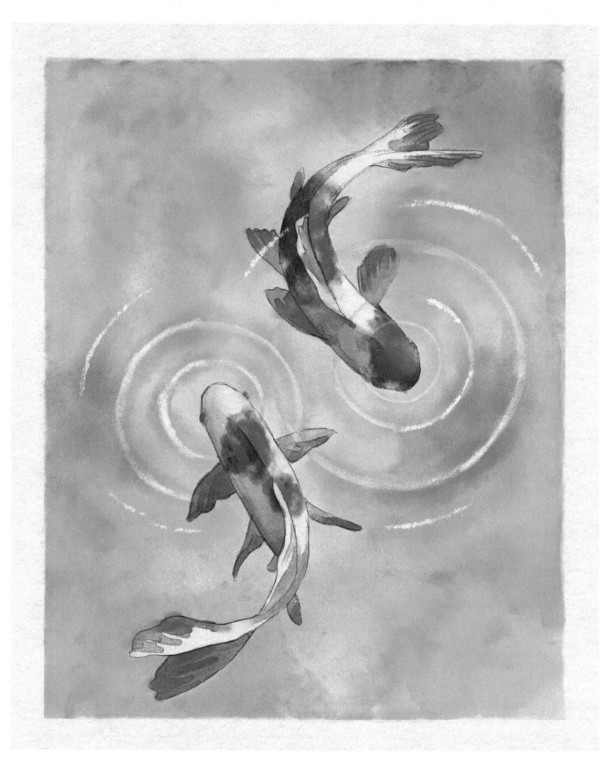

TIP: The wax crayon resist technique is an excellent option for creating highlights. Try adding some lightning to a stormy skyscape, like the one in Lesson 4 (Value, page 29).

Lighthouse on the Coast

This landscape painting advances the skills and subject matter from Lessons 1, Color, and 4, Value (pages 14 and 29), and combines loose painting techniques for the water and sky with the carefully planned lighthouse structure.

MATERIALS: Watercolor pad or canvas (rough cold press), masking tape, mixing palette, 2 jars of water, pencil, number 8 round brush, number 4 round brush, fan brush (optional)

COLOR PALETTE: Ultramarine Blue, Ivory Black, Cerulean Blue, Chinese White, Burnt Sienna, Yellow Ochre, Crimson Red

STEP 1: Sketch the lighthouse structure and surrounding bluffs slightly to one side, filling two-thirds of the paper vertically. The outline of the clouds can be very slight, just a suggestion for where they will be.

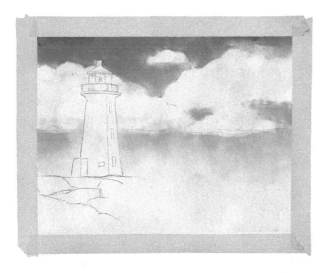

STEP 2: Next, use a gradient wash (page 12), starting with a mix of Ultramarine Blue and a tiny amount of Ivory Black, graduating down to Cerulean Blue, and your number 8 round brush to add in the sky. The wash might be split in two by the space left for your clouds, so add a little extra water below the cloud line to give the illusion of the gradient continuing behind them. Let the paint fade before it touches the horizon.

STEP 3: Create a mixture of very thin Ivory Black, a tiny amount of Cerulean Blue, and a small amount of Chinese White. Use your number 8 round brush with the mixture to define the underbelly of the clouds, add a bit of shadow to the lighthouse, and create a base layer for the rock beneath the lighthouse.

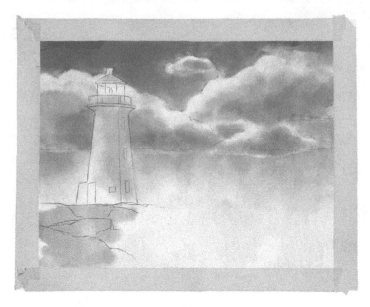

STEP 4: Add a tiny bit more Ivory Black to your mixture and use it to add one more layer of shadow to the bottom of the clouds.

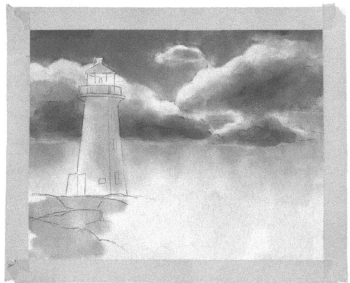

STEP 5: Wash your brush and mix the sea color, combining Cerulean Blue with a little bit of Burnt Sienna. Use your number 8 round or a fan brush (if using) to paint the water, right to left, with a sweeping gesture upward as it reaches the lighthouse. Envision your brush being turned away by the harsh rock face. For extra texture, you can splatter the paint a little at the end of the wave, tapping the brush against your finger to fling specks at the paper.

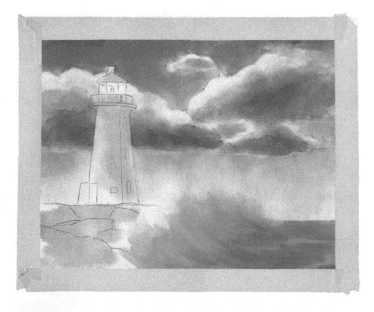

STEP 6: Use your number 8 round brush and an extremely thin mix of Ivory Black to add the murky gray rock formations directly beneath the lighthouse, ensuring you leave a little gap around the sea wave to give the impression of foam spray. Mix a tiny dab of Yellow Ochre and Cerulean Blue into the gray and use this to paint the area closer to the edge of the paper, graduating it into the pure gray rocks. Add another layer of shadow in the same colors.

STEP 7: Now, paint the lighthouse itself with a thin gray (Ivory Black and Chinese White) mixture for the body and Crimson Red top (wash your brush between colors). Use a 1-inch flat brush for the larger areas and a number 4 round brush for the fine details at the top. The right side of the lighthouse should be darkest.

STEP 8: Finally, when the lighthouse is dry, use the tip of your number 4 round brush to add the doors, windows, and guardrail to the top using Ivory Black paint. After the artwork is dry, remove the masking tape for a clean border.

TIP: Always keep your light source in mind with landscape paintings. For this project, the sun seems to be off to the left, behind the clouds and high in the sky. Different times of day can give very different lighting effects to think about, including the tones of your palette and the length of shadows.

Galaxy in a Teacup

For our penultimate project, we'll be combining the mundane with the fantastical in this playful piece—a teacup full of stars! The cup and saucer will use your still life skills, and the galaxy will need a much more controlled version of the previously practiced salt technique in Project 3 (page 49).

MATERIALS: Watercolor pad or canvas (rough cold press), masking tape, mixing palette, 2 jars of water, pencil, number 8 round brush, 1-inch flat brush, kitchen salt, number 4 round brush

COLOR PALETTE: Yellow Ochre, Cerulean Blue, Crimson Red, Ultramarine Blue, Chinese White

STEP 1: Sketch your teacup. It should fill as much of the paper as possible and be angled so that the liquid within can be seen fully.

STEP 2: Use a number 8 round or 1-inch flat brush to surround the subject with a thin Yellow Ochre wash, taking care around the edges of the cup and saucer. Let this wash dry.

STEP 3: For the galaxy base, use a number 8 round brush to add a watery Cerulean Blue wet-on-wet wash (page 11). Add a few patches of pink (Crimson Red mixed with a tiny bit of Ultramarine Blue).

STEP 4: Add your kitchen salt on top immediately, and then wait for it to dry.

STEP 5: Use the leftover paint from the galaxy—watered down to be very thin—and a number 4 round brush to paint wet-on-dry shadows around the cup, taking care to leave the rim and the various highlights unpainted so that the white of the paper shines through. The darkest shadows should be more purple and lighter ones bluer.

STEP 6: Continue with this paint, adding a subtle shadow to the teaspoon beside the cup.

STEP 7: Use a number 4 round brush and pink paint (Crimson Red, a tiny bit of Ultramarine Blue, and a little bit of Chinese White) to cover the napkin beneath the cup. Wait for everything to dry.

STEP 8: To finish this painting and give the subject a further level of dimension, use a thin Ultramarine Blue mixture and number 4 round brush to add shadows to the napkin, saucer, and table below. After the artwork is dry, remove the masking tape for a clean border.

TIP: Cool blue shadows add a calm light to a piece, but you could try a deep red shadow instead to create a rich, warm atmosphere.

Portrait

Here we are at the end of our journey! Saving the best for last, we're ending with a portrait-painting project. This is a great culmination of everything you've learned throughout the book, as it combines so many of the techniques and skills, including large washes, small details, and layering shadows to build dimension, as well as one final new skill: dry-on-dry texture painting.

MATERIALS: Watercolor pad or canvas (rough cold press), masking tape, mixing palette, 2 jars of water, pencil, masking fluid, number 8 round brush, number 4 round brush, 1-inch flat brush

COLOR PALETTE: Burnt Umber, Cadmium Yellow, Cadmium Red, Ivory Black

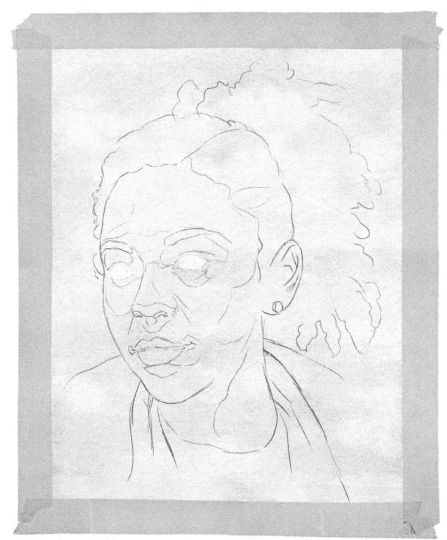

STEP 1: Pencil-sketch the face, including some basic lines to help define the facial features, ears, hair, and shoulders. Add some masking fluid to the whites of the eyes.

STEP 2: Apply a wet wash with your number 8 round brush using your base skin tone over the whole figure. In the example, it is a very watery Burnt Umber. For painting lighter skin tones, you can add a tiny bit of Cadmium Yellow and mix with a bit more water until your mixture matches the lightest parts of the skin of your reference. For darker skin tones, start with a thicker initial Burnt Umber.

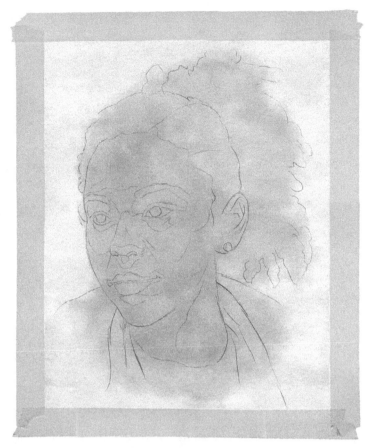

STEP 3: Using a darker shade of the same paint, add in shadows for the jaw, chin, nose, ears, and hair.

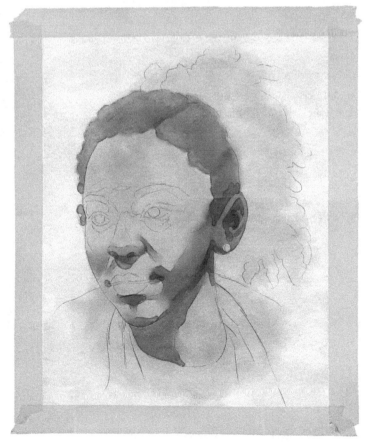

STEP 4: Remove the masking fluid. Using a number 4 round brush and the same darker skin tone as in step 3, define the facial features, including the eyebrows, forehead shadows, eye sockets, laugh lines, dimples, hair part, and neck base. Wait for the painting to dry.

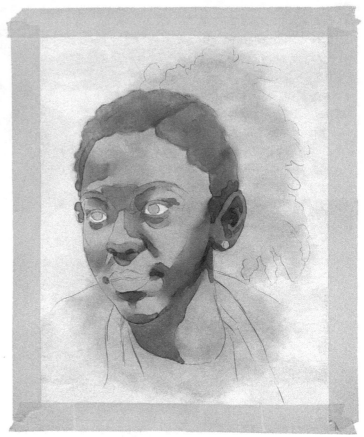

STEP 5: Using a thin Burnt Umber and a number 4 round brush, paint over the areas of shadows, giving them more dimension. Mix a thin Cadmium Red and use your number 4 round brush to shade over the lips, around the eyelids, and on the cheeks. Wait for this to dry.

STEP 6: Mix a dark brown (Burnt Umber and a little bit of Ivory Black) and use the tip of your number 4 round brush to paint the eyebrows, pupils, upper eyelid, upper lip, base of the nose, and shadow of the ear. Paint the hair with this shade as well, taking care to add texture using stippling techniques, short strokes, and varying amounts of water for shadowing.

STEP 7: With the same dark brown paint, use a loose wash with hard edges to bring the paint down around the neck area to suggest clothing. Then, use two mixes—a thick and a thin—alternately, dabbing the paint to create the loose back portion of the hair.

STEP 8: Use a dry 1-inch flat brush to pick up just a tiny bit of thick Burnt Umber paint on the tip. Add more texture to the hair by scraping the bristles in short strokes both along the braids and edges, as well as at the ends of the pouf.

STEP 9: Finish the painting with a vibrant Cadmium Yellow using your number 8 round brush to fill in the scarf. Use gradient fading toward the edge and mix in a bit of Burnt Umber to create the shadow around the neck. After the artwork is dry, remove the masking tape for a clean border.

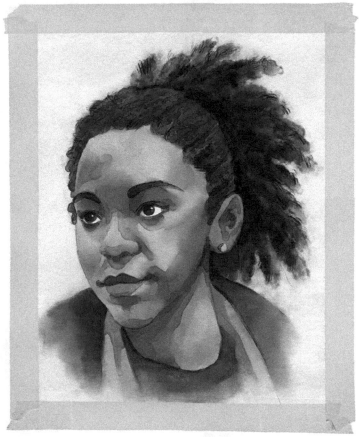

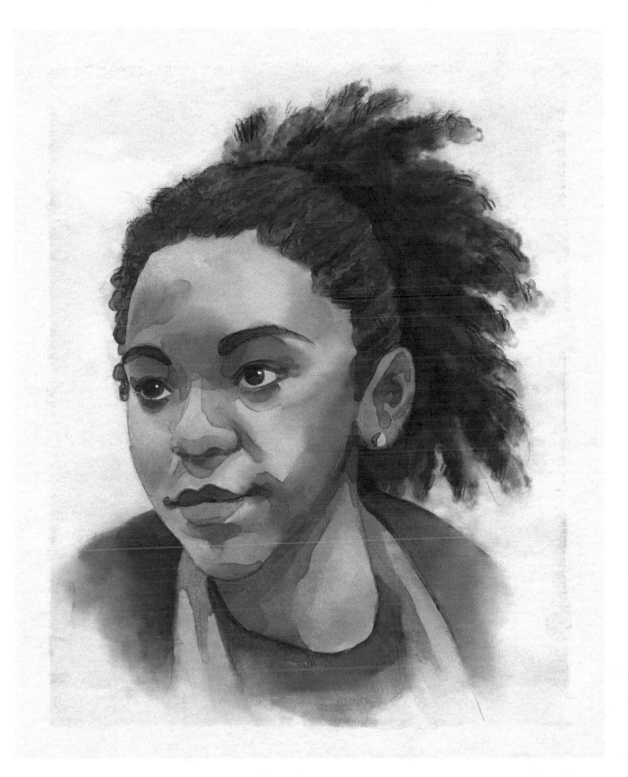

TIP: When painting humans, try to ignore the part of your brain attuned to reading facial features and imagine the face broken down into abstract shapes instead. Particularly study how shadows are cast by the brow, nose, and lips. It will feel strange at first but become natural with practice.

Glossary

abstract: An artistic style that features shape, line, and color not intended to depict realism

background: The part of the painting that appears to be the farthest from the viewer, behind any foreground subjects

bleed: Paint spreading beyond its initial boundary

color wheel: A visual tool designed to show the interaction among primary, secondary, and tertiary colors

complementary colors: Colors that exist on opposing ends of the color wheel

composition: The arrangement of subjects within a painting, particularly their spatial positioning

cool palettes: Limited selections of paint colors in which the dominant color is blue and the secondary and tertiary neighbors of blue on the color wheel

dab: A technique in which the paintbrush (or another tool) is pressed against canvas surface lightly and quickly

depth: The perceived distance of objects within a painting, created by value, saturation, or scale

expressionist: An artistic style that conveys the painter's subjective emotions through the distortion and exaggeration of shape and color

ferrule: The metal piece around the brush that holds the base of the bristles together

foreground: The part of the painting that appears to be closest to the viewer, in front of the background

gesso: A white paint mixture that includes a binding agent and is used as a primer to prepare canvas before painting

gradient: An area of paint transitioning from one color or shade to another, in smooth stages

graduated opacity: Opacity that increases or decreases steadily in stages

hues: Primary, secondary, or tertiary colors

negative space: The area that fills the space around the boundary of a subject

pigments: The ingredients in watercolor paints that determine the color

plein air: A type of painting where a piece is created from start to finish outdoors

representational: An artistic style that aims to show a true likeness of the subject

rule of thirds: A theory of composition in which the painting is divided into thirds horizontally and vertically

saturation: The intensity of color in an image

shade: A scale for colors varying from pure color to black

stippling: A technique where many small dots are used to create an image or texture

texture: The surface qualities of a painting, particularly rough or bumpy layers of paint

tones: Combinations of tint and shade mixtures, or a color mixed with gray

value: How light or dark a color or hue can be

warm palettes: Limited selections of paint colors in which the dominant colors are red and yellow and their secondary and tertiary neighbors on the color wheel

washes: Groups of watercolor techniques used to cover a large area with paint

Printed in the USA
CPSIA information can be obtained
at www.ICGtesting.com
CBHW082043220524
8972CB00007B/129

9 781638 783366